SUPERNATURAL SARATOGA

HAUNTED PLACES AND FAMOUS GHOSTS OF THE SPA CITY

MASON WINFIELD

Haunted America

Published by Haunted America

A Division of The History Press

Charleston, SC 29403

www.historypress.net

Copyright © 2009 by Mason Winfield

All rights reserved

First published 2009

Manufactured in the United States

ISBN 978.1.59629.700.5

Library of Congress Cataloging-in-Publication Data

Winfield, Mason.
Supernatural Saratoga : haunted places and famous ghosts of the spa city / Mason
Winfield.
p. cm.
ISBN 978-1-59629-700-5
1. Ghosts--New York (State)--Saratoga. 2. Haunted places--New York (State)--Saratoga. 3.
Tales--New York (State)--Saratoga. I. Title.
BF1472.U6W576 2009
133.109747'48--dc22
2009036416

For Irving Feldman
Poet, teacher and friend

CONTENTS

CONTENTS

INTRODUCTION

SPAS, STEEDS AND SPIRITS

I

The derivation of the name *Saratoga* is in debate. It surely comes from some Native American word, but a number of meanings have been proposed, including "Hillside Country of the Great River," "Place of Swift Water," "Place of Herrings" or "Place of Heel Tracks." Author Joe Bruchac has suggested an Abenaki translation: "Medicine Waters." That, especially, would make sense. The Native Americans came here because of the springs. They drank and bathed in the waters and hunted the animals that came to the salt licks.

The name could be a little deceptive, too. The county and region we call Saratoga today once comprised two distinct areas. *Kayaderossera*, "the Kaydeross" to the Native Americans and early settlers, was the territory above the angle of the Mohawk and Hudson Rivers, generally cut off by the Kaydeross Creek. The part called Saratoga is smaller—the area east of Saratoga Lake bounded by the Hudson. Even the town originally called Saratoga is today's Schuylerville, and the Battle of Saratoga didn't take place in the village. It was fought mostly in Stillwater.

From the beginning, the Saratoga region hosted a number of guests. It was routinely crisscrossed by travelers and traders, and many cultural influences have had an impact on the region, beginning with overlapping Native American groups. The Dutch influence radiated strongly throughout the Hudson Valley. French, English and American contingents held sway over

this region during the colonial period, and it experienced plenty of action in the various wars. By the twentieth century, the Kaydeross and Saratoga had become significant cultural melting pots, even though this may not have been their public face. Still, the Saratoga region would never have become what it is today without its namesake springs.

There are at least eighteen natural, underground water generators in the city today and numerous others outside of its boundaries. They are caused by a unique tossing of the geological strata here, bringing things that were once deeply hidden into the light. Some springs were known to the Native Americans, particularly High Rock Spring, next to which the first white settlements started in the 1770s. By the early 1800s, a substantial tourist trade based on the healing springs was up and running. Hotels and service industries quickly followed. The resort community brought with it a taste for the high life: gambling, horse racing and speakeasies. In that regard, Saratoga started to seem like a smaller and much more pastoral New York City.

Saratoga Springs' reputation as a summer hotspot has always attracted celebrities. Today, the region has many claims to fame. When Saratoga Springs comes to mind, the average person probably thinks of horses, dance and the high life as readily as natural fountains emanating from the earth. All of this—and the simple allure of being someplace that everybody else wants to be—accounts for the boom that Saratoga Springs, with few downward cycles, has enjoyed for more than two centuries.

Today, Saratoga Springs is the heart of this watery, hilly, historic region. It features an abundance of open land, four full seasons (including a vigorous winter), high arts and culture, measureless charm and a sheer sense of vibrancy that we would need a writer like F. Scott Fitzgerald to summarize in a single phrase. People from everywhere pass through Saratoga Springs on their way to and from northern New England or as a delightful stopover on a trip east or west.

Saratoga Springs is stereotyped as a resort for the rich. While hardly for the faint of wallet, this stereotype may only be true of Saratoga Springs in the month of August—racing season—when the city population triples. Saratoga Springs is a place of glamour and intrigue rather than outright splendor. It is a place that has a solid core, but it also puts up a veneer. Things are not always as they look, and everyone who knows the place knows that. But wherever there is a confluence of dramatic history, overlapping cultures and celebrity glitter, there is also psychic folklore. This book is about Saratoga's supernatural traditions.

II

When it comes to ghosts and the American public's relationship to them, there seems to be no middle ground between contemptuous disbelief and hook-line-and-sinker adherence to what I call "the TV theory." The TV theory holds that ghosts are the spirits of the dead and are back with "unfinished business." In the circles of research parapsychology, this default presumption is regarded as naïve.

Consider the typical eyewitness psychic report. Most are hopelessly fragmentary. Someone hears a funny sound, possibly a voice. A small object moves in a way that no law of physics can account for. A light or appliance turns itself on or off. An apparition—a ghost—manifests, is visible for a couple of heartbeats, makes no sound whatsoever and then vanishes in one of several ways. In fact, the average psychic experience resembles the TV ghost about as much as what you catch in your mousetrap resembles Mickey.

In some cases, psychic experiences do appear to carry a sense of order, and the lowest common denominator may be to suspect that some unknown force has acted. But those instances are rare and easy to distinguish from the typical report from a haunted house.

Too many people take the position that any snippet of psychic experience is the attempt of "a spirit" to communicate and that any detectable anomaly—a light blob on a photograph or a funny sound on a much-manipulated recording—is one more sign of a message. This is like believing you can deduce the full picture of a jigsaw puzzle from just a couple of scattered pieces. We need some alternate perspectives.

There are some interesting patterns in the way eyewitnesses relate their experiences, and there are correlations among the types of sites that attract generations of ghost stories. We do not need to talk about "spirits" to make some points.

III

Some of the tastiest bits in this book, including Native American and folkloric material, come from late Saratoga writers like Cornelius Durkee, Nathaniel Bartlett Sylvester, William Stone and Evelyn Barrett Britten. I broke up laughing more than once at their accounts, which perpetuated the morals of an earlier age that, truthfully, may not have been maintained in any. Historian Martha Stonequist has written many informative articles that

were helpful to this book. Historians Teri Blasko and Jamie Parillo helped me via last-minute phone conversations, as did my Saratoga friend, novelist Jeff Durstewitz. I had on-site research help of all types from Haunted History Ghost Walks tour guides Winifred Bowen, Jeff Brady and Rebecca Codner. They researched, interviewed and checked facts.

Two books were indispensable to a grasp of Saratoga Springs' architecture: the first by James Kettlewell and the second by Stephen Prokopoff and Joan Siegfried.

My understanding of Native American tradition comes from several sources. Harriett Maxwell Converse and Arthur Parker preserved classic Iroquois tales. Joe Bruchac has done the same for the Algonquins. Tuscarorora healer Ted Williams (1930–2005) and Seneca storyteller DuWayne "Duce" Bowen (1946–2006) were friends and teachers. Algonquin elder Michael Bastine is a constant resource, as well as a trusted friend. Abenaki author Joe Bruchac could not have been more generous with his time and learning.

Studies of Saratoga Springs' supernatural material do not exactly abound. The books of Harold Thompson and Louis C. Jones give us a window through which to view folkloric material from upstate New York. The Saratoga Springs Library has quite a file of old newspaper and magazine articles that help us realize what a tradition the supernatural is here. A lot of the material in this book was obtained through interviews with living witnesses, many of whom preferred to remain anonymous.

My perspectives on the ghost lore of Saratoga Springs are those of a paranormal generalist. For that sort of understanding, I am indebted, as always, to true scholars like Dr. William Roll, Paul Devereux, Colin Wilson and two much-missed, recently late authors, John Michell and John Beloff. Author/dowser/"earth mysteries" expert Sig Lonegren has been a mentor as well as a friend.

A special word needs to be said of David J. Pitkin, author of *Saratoga County Ghosts* (1998), the first book devoted to this side of the Saratoga region, and its 2005 update *Haunted Saratoga County*. It will be a long time before any book is written about this subject in this area without comparison to David's; he was the trailblazer in this region. He is an exhaustive researcher who misses nary a trick. You will not out-ghost David.

A book of this length could have been a ridiculously compressed listing of reports and sites. It could also have been made into a ghost-hunting profile of "investigations" at a handful of key sites. It might have gone out of its way to find sites and incidents that have never before appeared

in print. That would have been possible, if not to the point. Psychic folklore—"ghost stories"—truly is everywhere, and the Saratoga region is exceptionally rich.

Instead, this book is an overview, an attempt to look for significant patterns and coherence in the region's supernatural material. It even takes a shot at summarizing Saratoga's soul.

NATIVE SPIRITS

The Old Spirits

The earliest Native Americans may have settled and traveled through the Saratoga region for twelve thousand years. The first of them would have encountered the last of the megafauna—giant mammals—as the glaciers made their final retreat. In the years before the Contact Period, the population seems to have been light in this region. The Kaydeross was probably a hunting-fishing destination, with population centers elsewhere.

By the time of the European Middle Ages, two Native American groups frequented the region, the Mohawks of the Iroquois Confederacy and various Algonquin-speaking nations, including the Abenakis and the Mahicans. Representatives of the two language families didn't always get along very well, but there's quite an overlap between them in supernatural matters.

All Native Americans of the Northeast have a vivid belief in the spontaneous apparitions we call ghosts. Members of both Iroquoian and Algonquin groups report frequent sightings of ghosts and other psychic experiences at their traditional power sites. Among the Native Americans, the ghost sightings, as a rule, are not developed into classic tales like those of the Europeans. It is as if ghosts and related experiences are so natural and to be expected that no one bothers to think of them as remarkable. Only the occasional tale interests and thus lasts.

Tales of other types of folkloric curiosity are very developed. Inveterate storytellers, the Iroquois populated the wooded landscape with a variety of regional bogies. In this short chapter, I will offer a taste of the supernatural traditions of the Native Americans who still populate the Saratoga region.

GIANTS AND HEADS

Iroquois storytelling features many curious localized beings, peculiar to one area or region. Those that dominate the mythology tend to be man-form beasts: stone giants, great flying heads, vampire beings and little people.

The stone giants are a race of bestial cannibals at perpetual war with humanity. They aren't bright, but they're powerful and almost invulnerable to natural human weapons because of a caked-sand armor that coats their hairy skins. Some say that the bigfoot of the Northeast—often reported in

the Saratoga region—could have inspired the legends. The stone giants may be more like the Titans of Greek mythology. The absence of any readily visible stone giants is explained by their extermination—all but one—by the Great Spirit, paving the way for humanity to settle the Northeast. For some reason, the stone giants were associated with healing. One of the oldest origin myths of the magic, medicinal false faces concerns the last of the stone giants teaching the healing arts to a lost hunter.

Another group of supernatural beasts with more clout than smarts is the great flying heads. They are as they sound: giant human-style heads that hurl themselves about like birds. They are monstrous, too, with 1980s metal band manes, jagged teeth and bearlike arms. Sometimes they are described with small, energetic wings above the ears, but otherwise their flight seems magical. Though dangerous, they aren't fully inimical to humanity, at least when they aren't hungry. They, too, have been associated with the false faces.

I've met many witnesses to bigfoot-style critters in the Northeast, including a couple of cops in Whitehall, just north of Saratoga Springs. I have honestly never met anyone who reported seeing a flying head. I am not exactly disappointed.

THE VAMPIRES

Ever since Bram Stoker's *Dracula* and the films of Béla Lugosi, we've been stuck with the image of the vampire as a race of Byronic heroes and Gothic heroines, virtual demigods with a demonic flaw. Native Americans of the Northeast have tales and legends about something that answers to this general picture, but forget the runway models.

One version of the vampire is the war chief who dies of illness in his mature prime, is laid to rest with ceremony and then…comes back, to his village, his wife and his duties. In European tradition, you might call that a *revenant*, a returner. His temperament is not improved from his two-month death. In fact, it is as if something has entered the body of the chief and turned whatever is left of him to simple malevolence. He does as much damage to the world as he can get away with. He, too, is returned to the afterlife through the courage and resolve of the warriors of the village, but not without a lot of trauma.

Another variant is a reanimated corpse. A young family takes shelter in an isolated cabin in which the late owner's body lies. It comes to life in the night

and kills the sleeping husband. The wife grabs her infant daughter and runs like the wind. At the end of an all-night chase, she is rescued and ultimately avenged by the warriors of the nearest village.

Obviously, we are a long way from the Euro-style vampires of *Dark Shadows*, Anne Rice or *True Blood*. Nevertheless, the imagination is piqued. Is there something out there that has appeared to people around the world? Does the real thing, differently interpreted, account for the legends?

THE LITTLE PEOPLE

I

As English scholar Charles Williams observed about the belief in witchcraft, so many parts of the world have developed fairy lore that it's hard to trust any single explanation. Everywhere they are found, these little people are magical tricksters, as silly as children and as dangerous as wizards. They guard and honor special places in the natural environment. They have some association with the human dead and a special interest in human children.

They come to children, they protect children and sometimes they take children away.

Few Americans would guess the depth of belief in the little people of the Northeast, as rooted in time and tradition as those of the British Isles. The Algonquin folk I meet are reasonably relaxed about the little people, but you could get into trouble on many Iroquois Reservations for inquiring about them.

Little people are still spotted, and in unlikely quarters. Indeed, as simple paranormal phenomena, they are commonly reported by whites. One also wonders how much the well-known "imaginary friend" complex of American children could intrude on the little people. Often children see these amazingly gifted and intuitive "friends" as their own size or smaller.

II

The traditional little people lived in three different nations. "The People of the Underground Shadows" (sometimes called "the Hunters") almost never appear aboveground. They guard the gates to the underworld that pen the monsters of chaos. "The Stone-Throwers" care for the natural balance in the waters. The Saratoga region has a lot of lakes and streams, and there are more reports of these sorts of little people than in many other parts of the state. "The Little People of the Fruits and Grains" drive the natural cycles of the plants. The strawberry, which lines the road to the Iroquois heaven, is their special favorite.

Algonquin teacher and elder Michael Bastine tells us that many contemporary Native Americans report seeing only two types of little people: the small ones, probably figures of the third category above, who are powerful and kindly; and a knee-high sort, who are sinister and not always fond of humanity. It is the latter that are suspected to have that unhealthy interest in human children.

III

Wondrously wrought natural spots are often thought of as "little people places." Whether it's a big flat stone with its own tiny basin in the middle of a mighty stream; a tender rivulet strutting down the side of a shale cliff that could be a troll's stairway; a step waterfall in a creek that casts up a

crystalline spume; a geyser in a mound in the middle of a creek—these are little people places.

In the summer of 1667, three French fathers, probably Jesuits, were on a trail south of Lake Champlain when a strange, solemn mood came over their Mohawk escorts. They came to a beach littered with shards of the flinty material that Native Americans preferred for tools and weapons. Without a word, the Mohawks started gathering pieces of this flint. Their mood was that of people working a holy duty, even receiving gifts from the other world. The Jesuits just stood and watched.

When the journey resumed, the Mohawks explained that whenever they were near this spot they stopped and paid respects to the village of invisible people under the water. The little folk had made these flints ready for use, and they would do so as long as the Mohawk nation gave them tobacco in their ceremonies. These little water men, they said, traveled on the lake in stone canoes.

IV

The Native Americans refer to this watery stone-thrower group as "real ugly when you look at 'em." Though not ill-tempered, they have skinny, fishy faces.

While canoeing on the Sacandaga Reservoir, some of Joe Bruchac's Native American friends were shocked to find themselves overtaking a trio of little people. The little people move faster in their stone canoes than any human boat and even slip under the water when they choose. This trio was clearly up for a little fun.

"Somebody's gotta say something to them," said one of the little people in the Mohawk language about the boaters on their trail. "It's only polite."

"We don't wanna scare 'em," said the one in back. "I'll do it. I'm the best looking."

He turned to the humans and grinned as if having his picture taken. His face was narrow and streamlined like that of a fish. The stone canoe submerged smoothly, taking the little man and his grin with it.

"He was real ugly," said Joe with a big smile.

V

Abenaki author and teacher Joe Bruchac lives in the Greenfield home of his grandparents. He has a marvelous library and bookshop and a nature

preserve all around. When his children were young, he taught them to love the natural environment and not to fear the night or the woods. They spent many hours running, playing and hiking about the area, night or day. They even had a family game, sort of a tag/hide-and-seek/treasure hunt, running through the woods at all hours.

One night, one of Joe's boys came home breathless, gushing about mystery lights and little people. "Dad, I followed one of those lights," he said. "It came down in a clump of trees. I watched it till it faded out. There were little people, all around it." He watched them until it was fully dark and then ran back to the house to tell his tale. He was five at the time, and a few years later, he had no recollection of the event.

SHAPE-SHIFTERS

I

One of the prime powers of the witch or wizard anywhere in the world seems to be shape-shifting, usually into the form of a bird or animal, while continuing to think like a human. For the native witches of the Northeast, the choice was usually limited to a single favored form. One witch went about as a wolf, another as a pig and another as a goat. There is a particularly charming Onondaga (Iroquoian) tale with many variants about a midnight initiation in the woods and a shape-shifting display among the witches. Often observing an animal in a strange place, or even one behaving unnaturally, was a sign that someone may have seen a witch in animal form.

Witches make use of the animals' powers and disguise to serve purposes of their own, usually spying. There are many stories of these unusual animals being shot or struck by a human before running off. The next day, animal tracks and a trail of blood lead to the cabin of a suspected witch, whose body bears analogous wounds.

But an unusual situation is not all it takes to get the old-timers thinking that they might have seen a witch animal. Sometimes the apparently psychic forms are distorted or made of varied parts of other animals (a woodchuck with a bear head, rabbit paws, squirrel posture and a fox tail, for example). Even gutted deer walking on their hind legs have been reported near particularly troubled sites. Apparitions like these fall into a category that we might just call "witched." The observed critters hardly lend themselves to

interviews about their precise nature, and the observers don't stop to inquire. They are running like the bejesus.

II

A Mohawk woman living in the Saratoga region told me the following story. A friend of hers had left her horses out late and heard some commotion in the pasture. She went out to check on the horses and found them all in a far corner of the field, the stallion protectively out in front of them, looking intently in one direction. She saw two of her dogs, standing on their hind legs, leaning on the fence like a pair of baseball coaches, looking casually at the horses and then at each other as if rapt in conversation. As she got within hearing, one of them looked back at her and appeared to mutter something to the other. They fell back to all fours, waited for her to greet them and behaved naturally. They looked at her a little funny, that was all. Big mutts, both were grown dogs when she adopted them, and she always wondered about their background. After that, she wondered a little more.

WITCHES

Most world societies have legends and traditions about witches. The ones we meet in serious history seem not to be the Wiccan avant-garde of Margaret Murray and Marija Gimbutas, a pan-feminist movement repressed by left-brain, white male oligarchies; rather, they seem to be either downtrodden individuals taking a hopeful shortcut or the representatives of out-of-the-mainstream spirituality, usually that of a subject culture.

Some sources, for instance, feature the Genesee Valley Senecas claiming that their witches learned their trade from captives, possibly the Sauc (Sioux). The Onondagas, I've heard, might have gotten their magic from the Andastes. The Romans got their juju from subject peoples: Egyptians, Phoenicians, Etruscans. All of medieval Europe thought that the supplanted Celts and the wandering gypsies had the stuff. In the colonial U.S., there was a lot of voodoo and root magic perpetuated by slaves. Most Iroquois will tell you that witches were just people who bent "the Force" for their own gratification and vengeance, not for the healing of others.

Whatever anthropologists make of it, northeastern witches were clear power people. Belief in their traditions is far from over. Some Mohawks who

moved into an urban apartment became so convinced that it was spooked that they recruited my friend Michael Bastine to bail them out. (He commenced a tobacco/sage/smoke ritual that drove the forces upstairs through all the levels and out the attic, breaking a window in the process.)

There may have been an easier mixing of folk traditions in the Saratoga region than in most parts of the United States. German and Eastern European immigrants came here with many customs intact, and Native Americans lived among them. There was intermarriage, of both people and tradition. The witch lore of the Sacandaga Valley is especially well preserved in the books of Don Bowman.

It is hard to tell a witch by sight, unless you happen to be walking outside late on one of those crisp eves that the Kaydeross knows so well. When a witch is en route to some nightly deed or conclave, little lights shine inside him or her with each breath. When one coughs or clears a throat, this "internal luminosity" turns mouth and nostrils red as if a fiery bellows were within. If one coughs into a cupped hand, it is as if a flashlight were held in the palm.

SWIFTIE AT YADDO

I

To every dark, there is a light. The witch has an antithesis.

The medicine people are far more than simple doctors. In fact, they are workers in *orenda*, in *Manitou*. They help redirect "the Force." The old-time medicine people were counselors and diagnosticians, uncovering through their rites the source of a curse and the course of healing. Some of them specialized so much in anti-witchery that one didn't even bother them with toothaches.

Not every Native American in the Northeast is a healer or a witch, but he or she surely knows more about the business than you do. If you run afoul of either of them, you will know it quickly, and to your dismay. As a general rule, respect everyone. You have no idea what hidden talents anyone might have.

II

It is widely believed that most medicine people have psychic powers that they never use for show. To put on a display like today's TV mediums is considered child's play to the best of them.

Among the members of Joe Bruchac's late 1990s circle of friends was a seventy-year-old western Native American named Swift Eagle. Everyone just called him "Swiftie." It was sensed that he was an elder and was trained in old traditions of his Pueblo and Apache roots. Most Native North Americans tip their hats to the Southwest as the source of the continent's oldest surviving mystical traditions.

One afternoon, Joe and some friends—including Swiftie—were visiting Linda Hogan and Lewis Elder, native authors in residence at Yaddo, just east of the village of Saratoga Springs. It was Swiftie's first visit, and he knew nothing about the site or its former owners. He marveled at the grandeur of the former Trask estate—the mansion, the grounds, the setup and the personalities. As others socialized, the bemused Swiftie went for a little tour of his own.

After an hour, someone wondered about Swiftie, and the group set out in search of him. They found him by one of the lakes in rapt conversation with another guest, pointing to spots on the landscaped grounds, in the creeks and lakes and in the mansion itself. The guest, a newcomer to Yaddo, had mistaken him for one of the old-timers and asked him about the spirits of the place. As naturally as discussing the weather of the past week, Swiftie started walking her around, telling her the history of certain spots, including the spirit personalities he saw. As his friends came up to him, he was just finishing a tale about the pair of invisible women he detected.

Joe recalled David Pitkin's accounts of Yaddo and suspected that Swiftie had hit upon two of the most commonly suspected haunters, both twentieth-century women. Joe has learned to expect the miraculous among native elders, but this was still remarkable. Everyone looked at Swiftie with a new regard.

TWO LIGHTS ON THE HILL

I

Anomalous light phenomena—ALP—are fixtures of haunted sites. They are among the most commonly reported features of the old, drafty, abandoned buildings that become the typical village's haunted house. But they may be far more than that. The Native Americans of the Northeast have their own traditions about these lights. Iroquoians call them "witch lights."

Some of us who are non–Native American may have seen these smooth-moving spheres crossing the landscape at dusk. They come in varied sizes

and colors, though many are brightly hued and head sized. I have heard a few reports of fire-orange ones and even small ones the size of baseballs, though these are out of the pattern.

Witch lights are almost always presumed to be the markers, messengers or even the astral forms of witches. While they sometimes streak individually above the tree line and play pranks on observers, they also move in groups of a dozen or more. There are many zones and power places across the landscape where these lights are traditional. A few frequent-sighting zones in the Saratoga region include the Saratoga battlefield in Schuylerville, the Sacandaga Reservoir, Mourning Kill near Ballston Spa, Snake Hill on the east side of Saratoga Lake, Devil's Den to the north of the village of Saratoga Springs and, in the old days, Bear Swamp, just east of the village.

II

Iroquoians tend to be suspicious of moving outdoor lights. Many is the tale about a traveler wandering in a swamp and coming across one of these supernatural lights standing still a few feet over a spot in the muck. Wisely, the trapper or fisherman freezes, conceals himself and barely breathes. Soon, one of the villagers who is suspected of being a witch arrives at the spot, guided by the light. He or she digs around, hauls up something creepy and heads off. The light source smoothly and completely dims.

Some legends describe these witch lights as fiery orange balls launching like flares out of the chimney of a suspected witch, streaking above the tree line, coming to rest in a grim place—a graveyard or swamp—and taking shape as the witch. The light can be the astral form in which the power person chooses to travel.

Other tales are different. A hunter waits in the woods at night as several of the lights drift by. He freezes, barely daring to breathe. As one passes close, he sees the faint image of a human face inside the sphere—a power-person, living or dead.

III

Algonquin groups are not suspicious of all light spheres. Only the ones with a greenish cast are likely to be witches or nether beings, thus objects of

dread. The lights that are pure white are often thought to be clear human souls on their journey after the death of the body.

The Abenakis have a custom that when a person dies and manifests as one of these pale lights, some young and confused souls can become lost. They need help finding their way to the high places that launch them into the realm of the ever blessed. The big buck deer, with their broad-spreading antlers, can find and catch these light forms, herd them to the highest hill nearby and loft them into the hereafter. What a spectacle that would be—those broad tines lit by the suspended lights of souls! It is said that sometimes these creatures are too good for their own good, mistaking the headlights of cars for the wandering human souls they could be saving.

IV

During the Great Depression, an influenza epidemic swept the Northeast, and several of Joe Bruchac's family members were lost. His grandfather Bowman was one of them, breathing his last in their house in the region of Cole Hill in Greenfield. As he neared his end, he asked about Eddie, his beloved grandson. No one had the heart to tell him that, only hours before, the ailment had taken him, too.

Shortly after Grandpa Bowman passed, someone looked out the window and called everyone's attention. There, on the open ground outside the home, was a small, white, luminous orb, clearly one of the spirit lights. It moved timidly, as if confused. No one could account for its movements. It was as if it wanted to enter the house.

Only then did someone spot a much larger, brilliant orb, as much above the expected size as the other was below it. The little one circled the big and danced like a water bug on the surface of a pond, as frantic as a puppy cavorting before its owner. The little light's movements slowed and became more like those of the big one. The pair seemed to reach a resolution and moved smoothly together into the trees and up Cole Hill.

It was interpreted that the confused, earlier-passing soul of the grandson met the solider form of its elder. Grandpa Bowman's soul would know its way to the land of the Great Spirit. One like his could have led a herd of others with it.

SPOOK, SNAKE AND DEVIL

Power Places of the First Kind

T he classical world believed that there were two kinds of holy spaces:
those the gods had made sacred by the investment of earthly power
or atmosphere—Niagara Falls might be a too-obvious example—and man-
made sites or monuments that people had consecrated through deliberate
effort and generations of devotion.

The world's most famous ancient monuments tend to be both, not only
traditional ceremonial centers but also places that display a connection to
geological features—springs, fountains, gas wells and faults. The matter
should need little proving.

Springs all over the world have been associated with nymphs, naiads
and Marian apparitions. Delphi's Oracle and Buffalo, New York's Father
Baker had their visions over gas wells. The sites of Ohio's Serpent Mound
and France's megalithic complex at Carnac are both heavily marked with
faulting. Their relevance to a book on ghosts comes due to the fact that
these sites, natural or man-made, tend to be batteries for psychic folklore.
The Saratoga region is so rich in power centers of the first kind that it calls
for examination.

Algonquin societies had a word for the force that was in the landscape,
in beings and in actions. It was *Manitou.* You see it surface in many place
names around the Great Lakes and (often much misunderstood) in the
occasional film or novel. The Iroquois had a couple of power words
themselves. *Orenda*—the name of a spring at Saratoga Spa State Park—was
the positive word. In *Star Wars* terms, it might be translated as "the Force."

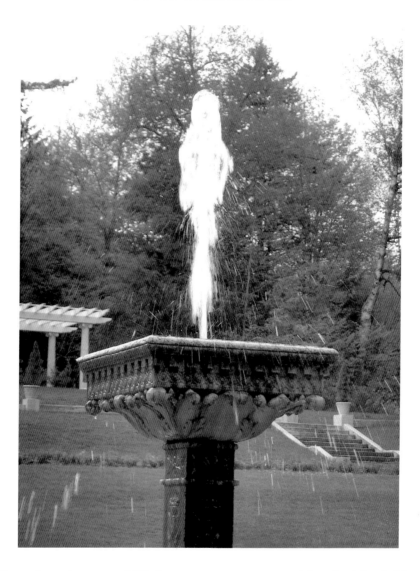

The universal energy of life, it permeates every material and spiritual thing. It concentrates in some natural spaces. It may survive in site tradition and in place names.

When whites encountered these power spots, they reached for the first term that came to mind, often biblically influenced: snake, devil or "spook" (a not totally respectful generic term for unspecified invisible influences). These place names might seem casual to the average observer, but they can be signs of something: the European mind, at the contact point, reaching to categorize something that the early inhabitants of the land knew well and

coming up with default terms. This chapter is about places of big *Manitou* and mighty *orenda*. There are more of them in this region of springs and faults than I can list and countless more that we will never know. Supernatural folklore is often the way we know them.

SNAKE HILL

Snake Hill is the conspicuous hill and promontory that juts out from the eastern shore of Saratoga Lake. You can't miss it as you drive around or boat on the lake. It is a curious piece of geology, and it is coupled with others.

Locals will tell you that most parts of Saratoga Lake are not more than a dozen feet deep. On bright, still days, the bottom is often visible. But just offshore from Snake Hill are some very deep places said to go 250 feet down. The bass breed and grow down there, they say—a fine place for fishing. Something weighted and dropped into that abyss would be there a long time.

Where did Snake Hill get its name? Some conjecture that a local who liked his privacy lived there and generated the legend of rattlers—bigger, badder and more profuse than anywhere in the region. Other stories concern a white man who raised rattlers and showed off his control of them to the public. (One day, one of them bit him and that was that.) Still another rumor concerns an Algonquin who collected an abnormal bounty turning in the rattles themselves, taken as evidence of death. It turns out that he was raising and harvesting the poor critters, cutting off just the rattles and waiting for them to grow back. Many other tales must be out there, but it's also likely that there's more profundity to the matter. Snake Hill is a site of legend to the Native Americans, and this is one of those power nicknames.

The Mohawks have a tale about a valiant old chief who was tortured to death here by the Algonquin. The Algonquins counter this with a "Lover's Leap" tale about a brave captive of their own delivered from the torture stake by a Mohawk chieftain's smitten daughter. Snake Hill features a high point from which the cornered pair are said to have plunged.

The times I have been on Snake Hill, the residents were hardly conversant, almost as if they had a reason to resent the supernatural theme. They could be hiding an ancient earthwork said to be here, one the archaeologists don't want us to know about. If it's a burial mound, it is both monument and graveyard.

Imagine Snake Hill against the starry sky! Strange light phenomena are occasionally reported at and over it. This could surely be imagined. The

Snake Hill.

lights of the houses on the hill glisten through the trees like gems against the wall of a cave. But UFO phenomena have been reported in the region, including an eerie and unnatural light above Snake Hill that may even have been a touchdown.

SPOOK HOLLOW ROAD

Spook Hollow Road in Stillwater is a short, generally north–south stretch about two and a half miles east of the top end of Saratoga Lake. It is one of those odd roads that is an unbroken stretch of another. What distinguishes Spook Hollow Road from a continuation of either Mabb or Cedar Springs Roads is a name change. There may be something curious in the fact that what we call Spook Hollow appears to be framed by two side roads that come in from the east at a *T*.

Modern Americans encounter so many crossing roads that we seldom read much into them. In the countryside of the preindustrial world, crossroads were much rarer. Since in medieval Europe witches and malefactors were

traditionally hanged at crossroads, a bit of supernatural tradition developed around any set of crossing paths. The *T* crossroad was thought to be particularly bad because it did not make the sign of the Christian cross. The *T* form was the shape of some of the day's gallows and was associated with the devil via the first letter of Taurus, hence the bull's horns connection.

Author David Pitkin speculates that Spook Hollow Road may have gotten its name from the fact that a longtime resident at a high point on the road was a well-known spiritualist. The family may have conducted so many séances in their home that the place became proverbial, especially after its owners had passed to the other side. This is certainly likely. Any old building known to have been involved with occultism of any sort tends to attract a few stories. It is also possible that that there is more to it than that.

I interviewed a New York state trooper who encountered some magic of his own on Spook Hollow Road. He was answering a call of some other sort when he encountered a phantom car. All he saw were lights and an erratic course. It was visible for a few hundred yards, possibly half a mile, and then it faded out. The manner of its disappearance, he reported, was "staticky." It was like bad reception on a TV screen.

DEVIL'S DEN

Devil's Den is an ample, indefinite region of the town of Saratoga, not far from the village core of Saratoga Springs. Doubtless, joggers and bikers who start at the new Skidmore Campus end up, unbeknownst to them, within its bounds.

As for why it would have been called Devil's Den, I have no understanding. Haunted History Ghost Walks tour guide Jeff Brady has uncovered some local gossip about witch covens and devil cults up there. The situation could go further back than that. I doubt that Devil's Den is a translation of an Iroquois or Abenaki term. Neither group has a true devil, at least not one like the Christian variety. It seems just as likely that Devil's Den was a holy region, and definitely a strong one. It probably had big *Manitou*, possibly an abundance of the twisty *orenda* associated with the good-minded spirit's trickster brother. Maybe there is just some story I haven't heard.

At any rate, this region is the focus of a number of legends, both pre-contact and twentieth century. Joe Bruchac retells a miraculous tale about his father tracking a bobcat to the region during the Great Depression and getting completely lost—"pixie-led," the Euros might call it. It should have

31

been impossible for any able-bodied person who walked twenty minutes in a single direction to get lost, but this skilled hunter managed.

Joe remembers a Native American lad who became a hippie in the early 1970s. During his days of living in the wild, he camped at Devil's Den. He had his own little teepee and campsite. He talked about the sights and sounds of the wooded, hilly area. "You see a lotta funny things out here at night," he said. "It's kinda cool." Joe recalls him talking about nocturnal lights, altered animal forms and a variety of unexplainable sounds.

Devil's Den was just one of the regions associated with the venerable "Witch of Saratoga," Angeline Tubbs. It is likely that she had her cabin here.

Today, this hilly, woody region they call Devil's Den still has quite a cachet with those in the know. There is enough undeveloped land and tree cover around Devil's Den to seem mysterious. I would recommend it as a vision site, if that's what you're looking for.

BEAR SWAMP

Even today, the eastern edges of the city of Saratoga Springs seem always wet. This is about all that stands of the once mighty Bear Swamp, less than a mile from the village, past the racetrack and on the way to Saratoga Lake. It was the setting for many wonder tales of natural animals and supernatural people who may have lived there.

Some Bear Swamp legends are merely prodigious. Revolutionary veteran and early settler Jacob Barhyte had his house on the site of today's Yaddo. One day, his wife was cutting pork. To a bear that came in the open door, the baby in its cradle looked like a sandwich. Forgetting the loaded musket that hung over the fireplace, the old gal came at the bear, big knife in hand. After a fearful struggle, she bested the beast, and the family had meat for weeks. There was also a major fire here in 1804 that nearly took the village. For a long time after, Bear Swamp was a mass of tree skeletons.

Some tales might be paranormal. Dr. Richard Allen, grandson of early settler Gideon Putnam, drove often through Bear Swamp, and his only radical tales come from it. Once, he saw what seemed to be a phantom pond, a large sheet of water just off the road. Wondering why he'd never noticed it before, he stopped and walked to it. It vanished as he neared.

A phantom building might have taken form here in 1843, like a castle of dreams in the middle of the swamp. Historian William Stone and some guests saw the lit-up building, which people on the train from Ballston Spa had

likewise reported. "The specter house" was thought to be a mirage, a reflection of one of the hotels from a long way off, but when you read the old accounts, this doesn't seem so confident an explanation. Many Irish and Scottish Celts would have another explanation: it was a quick look into Faeryland. One wonders what the Mohawks and Abenakis would have made of it.

Some reports are simply weird. They make Bear Swamp into a power site. Two mysterious early Saratogians known only as Buck and Crabb may well have been Bear Swamp bedfellows. Crabb was a solitary healer who claimed to cure "all maladies of ghostly spasm, or racking torture," as well as "epilepsies, asthmas, and moonstruck madness." Two of Crabb's wives died under strange circumstances. It was thought that at least one of them may have been poisoned. As for Buck, he was thought to be an outright wizard married to a witch. A pity that Crabb's wives lacked "the power." None other than Dr. Allen, on another Bear Swamp adventure, came by Crabb's cabin and found him the very picture of John Dee, Queen Elizabeth I's astrologer. Crabb was casting a horoscope on the floor, points of the Zodiac drawn, holding a skull in one hand and a witch hazel rod in the other and was surrounded by sulfurous flames from the "bases he placed on the outer rim."

Most of Bear Swamp is drained, cleared and developed by now, but in the low ground east of town you can still see traces of the damp that created it. A couple of haunted sites lie within its former boundaries. The restaurant Longfellow's, and even the formidable Yaddo, might be considered within its zone.

THE FAULT ON BROADWAY

Broadway Avenue in Saratoga Springs is an easy place to find ghost stories. Most American cities have at least one street where almost every building has some kind of psychic report. But not many American cities have a feature like that drastic drop-off, the fault that bisects the village of Saratoga Springs. Anyone who walks on Broadway will notice a steep drop to the east, but the best place to get a look at this fault is at the north edge of the city core, at High Rock Park. Just above High Rock Spring is a virtual wall. The coincidence of fault and phantoms may be no coincidence after all.

Author Paul Devereux notes the reports of strange, luminous, terrestrial orbs above some of the world's most sacred ancient monuments—Stonehenge, the Great Pyramid, Ohio's Serpent Mound. These orbs have been witnessed in association with the forming of crop circles. These "earth lights" sound

like a far different thing from swamp gas, Native American witch lights or UFOs. They have been reported many times above faults in the earth's crust. There is not necessarily anything supernatural about this.

It seems that geological forces deep underground can produce the appearance of lights on the surface. Eyewitnesses in the Andes have reported such lights seconds before the clash of tectonic plates that produces an earthquake. It is clear that many sites of paranormal reports have some connection to breaks in the earth's crust, like faults. Why couldn't hauntings? It could well be that psychic phenomena needs energy, even geomagnetic and electrical, to manifest. Sites that have plenty of the natural variety up the odds considerably.

HIGH ROCK SPRING

Irish-born Sir William Johnson (1715–1774) was the empire's "Indian" agent in North America. He took a shine to Mohawk women and had a long line of descendants of mixed blood. He was also a revered figure among the Mohawks, whom he led against a French/Algonquin force in September 1755. Sir William pulled out the Battle of Lake George but took a musket ball in the thigh that was never removed. It acted up on him ever after.

In the summer of 1767, Sir William suffered so terribly that the Mohawk council decided to reveal one of its most secret cures. Council members took him in a litter on a journey down the creeks and rivers and through the pine woods. One early morning in late August, he arrived at a fabled spring in today's Saratoga.

Sir William rose from his litter and unsteadily walked to the sacred fountain. He brought tobacco, which he ground and offered to the earth and winds. He used more to fill and light the calumet, the peace pipe that may have been a gift from Pontiac. He then drank from the fountain and reclined in its waters. He was there for four days.

When letters arrived calling him home, he stood and found that he could walk well enough to make some of the journey on foot. The renown of High Rock Springs may date to this visit. It was studied by many prominent doctors of the day.

Seven years later, Major General Philip Schuyler cut a road through the forest from Schuylerville to the High Rock and raised a tent, under which he and his family spent several weeks. In the coming years, they had many guests, but the accommodations were primitive. The spring was below the

short, steep cliff face made by the fault, as it is today, and surrounded by marsh. For a bathhouse, there was an open log hut. The waters themselves were collected in a big trough like those used for feeding pigs. People rolled into the trough from a bench that was kept beside it.

New springs were discovered in today's Saratoga village, and the "Springs" of Saratoga became a resort for those in pursuit of health and pleasure. For many years after its discovery, High Rock was the resort for people from all sections of the country, even when other springs were found in the neighboring village of Ball's Town, today's Ballston Spa, which for a time superseded Saratoga. Visitors from the east, north and south followed the road past the High Rock Springs. Joe Bruchac recalls the reputation of the place among his Abenaki ancestors: "You always have sightings at springs. We've got so many stories."

THE SACANDAGA

In the ancient Northeast, one traveled as much as one could on water. Sacandaga Creek was a vital joiner of travelers, hunters and traders between points south and west of Saratoga and those to the north. The creek and its portages cut the top of the clock face between the Mohawk and Hudson Rivers. The Great Sacandaga Lake is a new feature, however, made in 1930, when a dam was built over the creek between it and the Hudson River. A valley with a modest trough became a skinny lake, twenty-nine miles long and as wide as five miles. In the mysterious valley it covers, there was a lot of folklore. No wonder.

The Sacandaga Valley had been a multicultural place since the end of the Revolution. It had no true reservation of land for the Native Americans, but many folk of Iroquoian and Algonquin stock were here. French-Canadians and the occasional African American lived in the Sacandaga from early on, and by the late nineteenth century, many European immigrants had joined them. All brought their own customs to the isolated homesteads and small villages. The old Euro-style village "green witch" was no stranger in the Sacandaga. Many of the most potent healers—and the most formidable witches—were of mixed blood. Wherever we see this cultural overlap is fertile ground for folklore.

Sacanda is said to mean "Land of the Waving Grass," possibly for the vegetation along the creek meadows that used to be here. Today, the Sacandaga is a long, generally narrow lake used for recreation. But as a

folklore generator, this flooded valley north of Saratoga Springs is at the top. Its profile in that sense is similar to other "sacrificed" areas, like the Kinzua Dam in the western part of the state.

The five-year construction of the Kinzua Dam commenced in 1960. It flooded twenty-four miles and twenty-one thousand square acres of the Allegheny River Valley, including towns, villages, graveyards and homes. The people it affected most were the Senecas of the Allegany Reservation. It was a titanic national violation. During the long legal process, the extirpation and the five-year construction, psychic folklore in the hilly, wooded region abounded. It was as if all the bogies of the Iroquois regional imagination were coming back to protest the outrage—the Great Snake, phantom horses, the child-eater High Hat, shape-shifting witches, witch lights, Longnose, "the Legs." It wasn't just natives who saw them, either. White construction crews working in the area were frequently spooked. Even today, it is a zone of mysterious paranormal folklore. Bigfoot, giant water snakes, UFOs, mystery lights and underwater gnarlies are widely reported.

The affair of the Sacandaga wasn't quite as bad. The valley wasn't two-century-old reservation land, and the legal protest wasn't anything like the Kinzua battle. Still, the Sacandaga event was traumatic. Crews of laborers came in to fell buildings and whole woods. It would have had the look of a war zone.

Late author Don Bowman was the great preserver of the legends of this vibrant region. His books feature many tales of ghosts, witches, miracles and shape-shifters. Clearly, the Sacandaga is an energized area.

In Europe, archaeologists have found splendid gifts pitched into inland bodies of water, typically ponds and pools that had the reputation of being vision sites. The weapons, jewelry and even whole chariots were usually broken, leading scholars to wonder why ancient people had given their gods a pile of junk. Later, it came to be understood that the objects pitched into the water were given to the gods by being broken, thus ceremonially "killed." When we think of what lies at the bottom of the Sacandaga, we can't help but wonder if there could be some similar visionary effect.

THE GHOSTS OF WAR

Battlefield Ghosts

The Saratoga region has been a vital nexus for many centuries. It hosted clash after clash in the colonial wars and no one will know how many ancient clashes before. It is hard to be certain that any single piece of territory in either Kaydeross or Saratoga is innocent of some small-party clash. No wonder there is psychic folklore.

North American battlefields feature some interesting patterns. Many clash sites are deeply layered. In the Saratoga region, the vicinity of the Schuyler mansion is a good example. It hosted several forts and a series of historic clashes. It has had a couple of executions. If we turn west to some 1812-era fields in Buffalo, New York, we see that city clash sites overlap with sacred sites, burial grounds, military campgrounds and landscape design. It is as if human history has eventful pileups in certain very small regions.

A second pattern involves the fact that psychic folklore and report— "exceptional human experiences"—concentrate on these old battlefields even when the history is unpublicized. It is quite common on the heavily developed Niagara frontier, for instance, where historic sites are routinely overgrown by railroads, factories, strip malls and streets. Only history buffs and scholars know their blood-filled histories. It is as if the area of the old clash is "energized."

You might expect to find ghost stories surrounding battlefields, even if people don't know they're on such ground. But it is only at highly public sites that you hear of apparitions of historic combatants. At other, less publicized, sites, we get reports of the same generic phenomena as at most

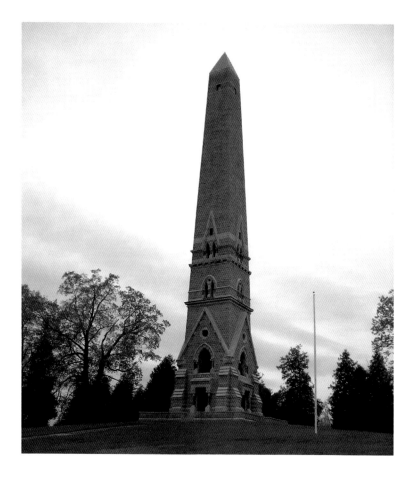

other haunts—lights, sounds, voices and human ghosts of the most generic types (little girls, women in white, domestic animals, horses and riders and the occasional old soldier). Just because we're near battlefield, can we be sure that a flickering shadow at the corner of our eyes is from an eighteenth-century clash and not one from, say, last year?

Maybe the Iroquois have it sorted out. My late friend, storyteller DuWayne "Duce" Bowen (1946–2006), always believed that the fabled power of a region near Salamanca, New York, was due to a battle that had taken place there in prehistory. Rather than projecting the ghosts of Iroquoian warriors, Witches' Walk holds energy that shows itself in a spectrum of apparitions, like the altered-animal forms and earthly light phenomena (witch lights) so common in Iroquoian folklore. So haunted was Witches' Walk that only power people dared tour it at night. Witches and sorcerers even came there to bathe in its energy.

Mourning Kill

Kill is a Dutch word for "creek," found often in the region's place names. Mourning Kill is one of the few places in which the English meaning could be as relevant.

The Saratoga region is marked with creeks, lakes and rivers, and canoes were wonderful for transporting goods or game. When the water routes didn't connect in the direction people were headed, there was a canoe-hauling march between the waterways called a *portage*, usually marked by a trail. Different sets of people ran into one another along the well-traveled routes. The Iroquois and the Algonquins didn't always get along.

Mourning Kill is a little stream that runs through the town of Ballston and twists and turns into the Kaydeross River. Between the creek called Mourning Kill and the outlet of Ballston Lake was a portage on one of the ancient trails between the Mohawk and St. Lawrence Rivers. It ran along a natural meadow. The creek and trail were a natural thoroughfare for thousands of years, and the area we call Mourning Kill today was a likely place for Native American groups to cross paths.

One morning in strawberry time, centuries before Columbus landed, half a thousand Mohawk men entered the Mourning Kill en route to the St. Lawrence River. An eagle had been circling over them since early dawn. As they entered the Mourning Kill, the first of the men noticed the kingly bird land on a high branch and look down on them. Before he could remark that something seemed strange, the leader of the Mohawks spotted the vanguard of an Adirondack band coming from the other direction. A wild fight broke out in the meadow, rich with wildflowers. War clubs, spears and flint-headed tomahawks leaped to the bloody play for which they had been made. Neither side gave ground in the first head-on clash. Then tactics changed.

"I would as soon be besieged by hobgoblins as by the Iroquois," said Jesuit Father Vimont. The Algonquin speakers were no slouches. Packs of men in small parties pounced on one another. Stealthy archers' work was no less deadly. The carnage in the trees shocked both sides, but neither would abandon the ground. All day, the eagle watched and hopped on its perch. It rose and circled whenever parties lagged and cheered them on with an almost human sense of glee when they clashed again. Both sides took it as a sign urging them to greater courage. The day would be remembered by the eagle—their eagle! New songs would be made and, for centuries, danced!

Vögel der Seele, Rilke called his angels. "Birds of the Soul." Some similar sense has been with many world cultures. Birds have been totems of the

spirit and of warrior cults. Some have been messengers and prophets. But as the long day dimmed with no resolution at Mourning Kill, a sense of revulsion crept over the men. The idea came to them that they had been fighting for nothing and not against their true foe.

The last beam of sunlight tipped the high pines as five hundred men stared at the evil bird. Five hundred bows lifted, and five hundred arrows launched as if by a single impulse. The critter fell to the earth, a mass of feathers and bloody bones, but hardly had it touched ground than a bright dove rose out of its tattered form. It flew up, and no one would strike it. The men parted and went their ways with only solemn glances at those they had been trying all day to kill. No man of this generation ever raised a hand against folk of the other tribe again. And ever after, the little stream has been called Mourning Kill.

For generations, the landscape about the scene remembered. The wild roses that sprouted in strawberry time came up no other color but red in natural memory of the loss and sacrifice. The effect may linger in the occasional rumor of mysterious lights at twilight in the region of today's Mourning Kill.

THE BATTLE OF STILES'S TAVERN

Let's go back to the late seventeenth century. The last two heavyweights fighting for control of the Northeast were the British and French. As in all wars, the motivation was territory and trade, the commodities of power. This struggle would finally settle itself on the doorstep of the American Revolution. Most of the French fighting was done through its Native American proxies, the Algonquin-speaking Abenakis and their allies in the Wabenaki Confederacy. It was all too easy to turn them against their ancestral enemies, the Iroquoian Mohawks.

In January 1693, Count de Frontenac, governor of Canada, sent a force out of Montreal with orders to ravage the Hudson Valley all the way to Fort Orange, a five-pointed star of a fort at today's Albany. Mohawk villages and English settlements stood in the way. One hundred French soldiers and a similar number of French-Canadian volunteers trekked south on snowshoes and crossed the frozen Lake Champlain. They picked up allies on the way—Abenakis, Hurons and Algonquins. By the time this coalition of Mohawk haters hit the Hudson, the whole party might have been 625 men, a good-sized bunch for the place and time. At night, they camped in snow foxholes, under roofs of hemlock branches.

In mid-February, they overwhelmed two Mohawk towns, taking three hundred captives, almost all women and children. The French plan was to drive all the way to Albany and deal a deathblow to Hudson Valley settlement. The Native Americans felt that the point had been made and that many prisoners would slow them down. The French and Native American band started heading back north.

Lieutenant John Schuyler of the famous Dutch settler family rounded up 55 horsemen. Joined by more Dutch-English militia and a bunch of ticked-off Mohawks, they crossed the Mohawk River after the enemy. These 273 men closed the gap on their foes, camping eight miles, then three and then one apart. This last site was near Greenfield Center, just a few miles north of Saratoga Springs in the town of Wilton.

The French and Native American party made a quick fort, a northeastern-style palisade of tree trunks. Just a little ways off, possibly within eyesight, the Mohawks started building their own. The plan seemed to be to launch an infuriating version of siege warfare, frontier style. This, the French coalition could not abide. They sallied out to drive the pro-English alliance back. There was some shooting but a lot more struggling with sword, war club and tomahawk. Blood spilled on the snow. Bodies lay in the trees.

This first rush was driven back. A French priest, Father Gay, rallied his native troops with analogies and exhortations of dubious relevance. He got them fighting, all right, but three more rushes were blunted. The pro-French crew camped behind its barricades for the night. A squall settled in.

The English woke snow covered and famished, completely out of provisions. Their Mohawk allies, just tucking into breakfast, looked pretty chipper. They had some surprise source of provenance that appeared to be a hearty soup. They invited their English friends to partake. When a human hand was ladled into Lieutenant Schuyler's bowl, it became clear that the Mohawks were supping on their opponents. He decided to fast a little longer.

Throughout the next night, the bands watched each other, waiting for a move. By morning, the French had taken off under cover of the storm. Some provisions arrived, and Schuyler's men set out in pursuit. As they neared their foes, word got back that if the fight started again, the prisoners would all die first. The Mohawks refused to risk this, and the foray ended.

The site of the Battle of Wilton (sometimes called "Stiles's Tavern") is marked by a plaque at the corner of Parkhurst and Gailor Roads. When we reflect on the flurry of psychic reports that flare up at the site of even a recent murder or suicide, it should be no surprise that hauntings flock to this collective disaster. Author David Pitkin notes a wave of them.

More than a century after the pivotal battle, settler Benjamin Philips's homestead went up on the site. Not many years later, he sold it to Ruben Stiles, whose family ran a tavern for over eight decades. By the early twentieth century, the site had been reconverted to residence, whose many occupants believed they had company. Reported phenomena included "apports"—mysterious appearances—of buttons and the sounds of faint music and phantom dancers in the former ballroom. A house-sitter observed a fairly dramatic array of poltergeist phenomena, including bedroom hijinks and the familiar electrical pranks—lights and appliances turning themselves off or on. However, this stuff is just SPOTUK, as I call it: Spooky Phenomena Of The Usual Kind.

"The Corners" has other reports. Pitkin mentions a nearby house from which the classic LGG—Little Girl Ghost—peers in the garb of an earlier day. He discusses reports of outdoor apparitions, including a legless man seated by the roadside and an old gent looking for something in the underbrush. None look like colonial-era scrappers or Native American warriors. It is hard to believe that the locals don't know of the site's bloody past. The marker is out there for all to see. It seems likely that the site has some mojo of its own that surfaces in generic psychic folklore.

THE DAWN OF THE LIGHT

It was the fall of 1693. A big party of Mohawks on their autumn hunt were comfortably camped along Saratoga Lake in the vicinity of Snake Hill. It was customary for them to get as much game as they could before the New York winter set in. They returned with it to their Mohawk Valley villages in a grand and joyous procession.

After a couple of days of fine hunting and fishing, they were surprised by the arrival of a pair of Hurons. These men claimed to be deserters, and they had a story to tell. The French-Algonquin expedition of Count Frontenac was just two days away. For some reason, the Mohawks had started to call this arrogant and vengeful man *Yonnondio* (also *Onnotio*), probably meaning, "Great Mountain." The Great Mountain's large force was closing in on Saratoga Lake, planning to surround and capture the Mohawk party. It is hard to surprise a Mohawk in the woods, and the Flint People plotted an ambush.

The two Hurons had more to say. The approaching force had more soldiers than the Mohawk men, women and children combined, and it brought strange

weapons. The Hurons' attempt to describe cannon and mortars made Great Mountain sound like a sorcerer to the lightly armed Mohawks. Open battle, even a classic Mohawk ambush, was a stupid idea. The chiefs debated their course of action sitting around a fire on Snake Hill, and word went out that the counsel of their oldest chief, Thurensera, was needed.

Thurensera is a name said to mean, "the Dawn of the Light." The man who claimed it was over a century old. A handful of young Mohawk men darted off and returned with the frail, white-haired leader on a litter. No one would gather from looking at him how agile he had been in his prime. As he rested at the foot of a sycamore tree, all eyes were on him.

As if he had trouble rousing himself to focus on this world, he asked why he had been brought to them and why they would want the counsel of someone so soon to be called by the Great Spirit into the other world. He asked why they looked so downcast. When he heard the story of the approaching thunder weapons, he had a plan.

"You can't stay and fight this force alone," he said. "Not until you can unite with the other Iroquois nations can you come back and strike a blow. But before the Mohawk can teach the invaders to fear them, someone has to show them how a Mohawk can die. I will stay here to meet them." At this, the whole camp took a breath. They knew the grandfather they revered would be tortured and killed by his enemies.

Thurensera was unmoved. He told them to find his bones by the torture stake when they returned in triumph to Saratoga Lake. He told them how he wanted to be buried, with his pipe, his canoe, his tomahawk and his bow, on Snake Hill. He made his goodbyes, declaring them the last words he would speak. Then he took a Zen-style pose and faced the direction from which the invaders were expected. After becoming convinced that this was the old chief's wishes, his people loaded their belongings, fired their wigwams and filed by him one by one to give their last words. Poised like a resolute Buddha, the Dawn of the Light waited alone on Snake Hill.

Amid the bustle of his guards and baggage carts, the man called Great Mountain looked into the early sunset above the narrow trail and asked why there was so much smoke above Snake Hill. His Huron and Algonquin scouts crept out to reconnoiter. They reported that it was the burning of the Mohawk wigwams. The army crept closer, still wary of the dreaded Mohawk ambush. Soon, the scouts found the old chief waiting like a living statue.

The French count approached. Through interpreters, he asked a few questions. The Mohawk just looked ahead of him with an intent gaze. Then, to Frontenac's great disgrace, he let his native allies have at the old chief.

Not a word did the Mohawk utter. They asked him for information about his people, and he replied with a contemptuous laugh. When he felt his last breaths approaching, what was left of him addressed the jeering throng.

He warned the French and the Algonquins of what was to come. A different white power, the English, was coming to drive the French off the continent. The Algonquins would be beaten back to their territory, with losses along the way. "Think of me, torturers, when my sons come upon you!" he finished. "Great Spirit! I come!"

All he forecasted came to pass. Doubtless, what was left of his body was left on display in plain sight—as if to frighten the Mohawks. His burial went as planned, and all fell as he foretold. Today, Snake Hill, the place of the old chief's grave, is a site of paranormal allure. Which of the mystery lights on the hill is a blink of the *orenda* of the Dawn of the Light?

FOUR FORTS

Saratoga was the Native American name for the region between Saratoga Lake and the Hudson River. When old histories use this term, they are referring to either this region or the first name of the old settlements at today's Schuylerville. The first European visitors readily spotted military potential at a Hudson River meadow by Fish Creek, just south of today's village. This site is a bottleneck, cutting off ancient trails and a lot of traffic up and down the Hudson. Four forts—Vrooman, Saratoga, Clinton and Hardy—were so close to one another that a single marker suffices for all. Considering the number of clashes that took place here, it is no wonder that it is a little paranormal zone.

The first fortification here was the simple wooden Fort Vrooman (1689), a stockade around the home of Bartel Vrooman. It was destroyed by a French/ Native American incursion in 1695, part of the cycle of forays that did so much damage to the Mohawks in the region.

By 1709, it was rebuilt, renamed Fort Saratoga and reinforced a couple of times thereafter. In 1744, another round of war between England and France was declared. On November 16, 1745, six hundred Frenchmen and native allies swarmed on the small, wooden Saratoga, burning it and twenty houses. Thirty people were killed and scalped, among them Philip Schuyler, lord of the fine estate.

Rebuilt again, the fort was renamed twice after New York governors—in 1745, for Charles Clinton, and in 1757, for Charles Hardy. This accounts

for a bit of confusion. By the 1740s, this stretch of flatland along Route 4 hosted English homes, farms and forts, as well as Philip Schuyler's plantation. Among the number of traumas at the site was Schuyler's use and quartering of slaves. There were war clashes here, too.

On August 29, 1746, a band of French and Indians took the occasion to jump twenty English soldiers near the gates of Fort Clinton. Four were killed and scalped, and four were taken prisoner.

Inspired by that success, a full pro-French expedition sallied out from Fort St. Frederick in June 1747. Twenty Frenchmen and 200 native allies arrived outside Fort Clinton on the night of the eleventh. At daybreak, they drew 120 angry Englishmen out of the gates, right into an ambush. The English stood their ground, and the fort's cannons sent canister (grapeshot) and other delights in the general direction of the French. The native allies charged the overmatched English and rushed them into the fort. Many English soldiers ran downhill into the Hudson and were drowned or tomahawked. Twenty-eight English soldiers were killed and scalped and 45 were taken prisoner. How many dead drifted downriver is unknown.

At the end of the last French and Indian War, English settlement returned under the protection of Fort Hardy, which was soon abandoned. The next conflict was a war between English speakers. The long, epic Battle of Saratoga in 1777 sprawled all over this smooth meadow by the Hudson. The fine rebuilt Schuyler mansion and most settlements in this vicinity were destroyed in the wake of the English retreat. Today, the historical markers and the fine preserved Schuyler House are about all there is to look at.

We hear reports of a variety of ghostly personalities in the Philip Schuyler House, seven miles north of the Saratoga Revolutionary battlefield. Among those that circulate in the community are apparitions of suffering soldiers on operating tables and medical personnel. The September 1777 version of the house that stands today was under British control during the two-week battle and was probably used as a hospital. Though destroyed in war action, the version that stands today was rebuilt quickly, likely on the same foundations. If a psychic aura can stand in a new site—as it seems it can—we have the explanation for some of our spooks.

In his books, David Pitkin lists other apparitions, not all of which have a connection to war or battle. The glowing apparition of a cigar smoker is attributed to the essence of a former slave on the site and was even named by the staff, "David." Phantom after-hours lights and little poltergeist-style pranks are included in the reports: phantom footfalls, bangs on the walls and even some invisible bully that shoves members of the staff. Something here

likes the tidy shaken up and the disorderly restored to order. An old-time newspaper on display, for instance, was insistently kept open to its usual page by some phantom hand.

THE BATTLE OF SARATOGA

Let's set the stage. The year 1777 was the second one of the American struggle for independence. The colonists had picked a heavyweight opponent, and one well situated in their midst. Many of the colonists themselves—often called Tories or Loyalists—were operating in the Crown's interests. Some of the worst atrocities of the war were perpetrated by one colonist upon another. The empire had few compunctions about what its paramilitaries and native allies did to the despised rebels. Depredations on frontier settlements, including massacres, were all part of sapping the colonials' will to compete.

In the summer of 1777, British commander "Gentleman" John Burgoyne and his eight-thousand-man army sallied out of Quebec and down the Hudson, taking Fort Ticonderoga, temporarily disgracing General Philip Schuyler, scattering opposition and preparing to cut New England off from the rest of the colonies by controlling the Hudson Valley. The Americans didn't know what Burgoyne was up to, and his native allies spread such a wake of terror through the woods around him that no one could spy on him. By September, it was obvious that he would need to go to winter quarters before the nor'easters started arriving.

Gentleman Johnny could have made the easy move—an almost unopposed retreat north to bases like Ticonderoga or Crown Point. Instead, he made the arrogant one—to attack, advancing the cause closer to the heart of the colonies and the rebel capital, Philadelphia. He may have felt the need to hurry. Before he left England, he had bet a friend that he would win the war within a year. To Gentleman Johnny, who toted thirty wagonloads of personal items, life looked like an easy trip. An author as well as a general, Burgoyne had written a bunch of hit plays, including *The Maid of the Oaks* and *The Heiress*. He thought he could do just about anything he wanted with so many redcoats in that part of the world. He had good reason to think this way.

The Continentals—largely an army of irregulars—had had, by then, no significant victories. The British Empire had a huge, seasoned, well-trained standing army. The best analogy may be to compare it to that of the Roman Empire. The Romans had made a study and practice of war, systematic

enough to be called a "war machine." Things had changed a lot around the world by the time Britannia ruled so much of it, but the British army was still the world's hardest, proudest and most professional force. Not even Napoleon would beat a British army at even strength. It seemed impossible for any number of farmers and blacksmiths to menace a force like Burgoyne's. Appearances confirmed this.

As Burgoyne moved south along the Hudson toward Albany, the Americans kept retreating. They destroyed bridges and felled trees to block the road on the west side of the Hudson. They ravaged the countryside of its supplies. At the high ground called Bemis Heights, they stopped retreating. If they didn't bottle up the British here, the dam would break.

Burgoyne made some dumb moves on his way to Saratoga. His native allies lost many lives in this campaign, but they also committed atrocities. Burgoyne neither honored the one nor curtailed the other, simultaneously rousing the countryside against him and offending and driving off his forest fighters. Like the Roman army, the big redcoat machine wasn't set up for forest fighting, and the woods around Burgoyne were open to the American rangers. Burgoyne also sent out ill-advised expeditions and lost more of his total force. (On one of these missions in Bennington, Vermont, William Walworth, ancestor of one of our ghosts, was twice taken prisoner by the British and twice escaped.)

Possibly the worst decision Burgoyne made was to underestimate the difficulty of maintaining supply lines for his army. By the time Gentleman Johnny was in the tussle at Saratoga (today's Stillwater and Schuylerville) against nine thousand determined Continentals, it was too late to do much about it.

The first heavy clash on September 19 was a British attempt on some territory around the farm of Loyalist John Freeman. It was a whirlwind affair, with many twists and turns. The British took the ground at Freeman's Farm, but with heavier losses than the Americans. Already outnumbered, this they could ill afford.

A fortnight of skirmishing and sniping followed, with British supplies and reinforcements delayed and American ranks swelling. By October 3, the last British rush on Bemis Heights was an all-or-nothing roll. It took another two weeks for Burgoyne to get the message. Surrounded and by then outnumbered three to one, Burgoyne gave in on October 19.

The Stillwater battle had instant consequences, including a head slap to the British war effort and a shot in the arm to the American one. Saratoga convinced the French—who were still peeved at the English for having won

the continent—that it was worth some energy to support the Americans. Supplies, money and even troops started coming their way.

Massive political developments often have folkloric echoes. The American heroes of the Saratoga affair are household names to many of us. Some of them come back as mighty serviceable ghosts.

Widely remembered as a national traitor, Benedict Arnold (1741–1801) was a hero at Saratoga, leading a mad, unauthorized, whiskey-sodden charge that won a key position for the Americans at Bemis Heights. The Norwichtown, Connecticut grave of Arnold's mother, Hannah, is said to be visited every Halloween by a spectral figure in a tricorn hat, an apparition widely presumed to be that of America's number one turncoat.

Daniel Morgan (1736–1802) was the brawling Welsh-American leader of the Virginia Riflemen at Saratoga and the hero of the 1781 Battle of Cowpens, South Carolina. For slugging a British officer in pre-Revolutionary days, he was given the barbaric and usually fatal sentence of 500 strokes of the lash. Morgan stayed conscious, counted every blow, insisted that he'd been given only 499 and claimed that he owed the British one back. There's a rumor that someone haunts Morgan's Frederick County, Virginia home, known as Saratoga. Folklore naturally presumes it is Morgan.

Lieutenant Thomas Boyd (1756–1779) may have been leading a wing of Pennsylvania riflemen at Freeman's Farm. Holding the line against a British rush, he may have turned the first Saratoga clash by himself. He was surely involved in other incidents across the Northeast. On picket duty near Canajoharie in 1778, he singlehandedly captured two notorious Tories—Lieutenant Rolf Hare and Sergeant Gilbert Newbury. He miserably dumped a loving, pregnant fiancée, maybe even drawing his sword to back her off as his regiment marched out. Apparitions and other psychic effects associated directly with Boyd come due to his 1779 service in General Sullivan's Western New York campaign and his unfortunate death in the terrible 1779 Genesee Valley incident of the Torture Tree.

So much for folklore, which tends to fix upon famous individuals without direct evidence. The battlefield at Saratoga is a complex site, with spots of hospitals, burials and clashes, many not precisely known. It is logical that residents of the region would report effects that can't be identified. I wouldn't expect much of it to act up precisely as you visit.

Over the decades, however, motorists on Route 4 along the Hudson and on roads all across the big region have cited ghostly forms that do not come from popular films. They don't see whole armies, but handfuls of men, sometimes in broad daylight, in the road haze of steamy, sunny June days,

and not always in the costumes one would expect. Some drive right through them, stopping and running back to look for bodies. None are ever found. Tourists at the park now and then report the images of period combatants, often simply walking or running. Sometimes it takes a historian to sort out the affiliation of the apparitions. Sometimes only people at precise distant spots can see them, as if the matter is truly one of light and shade. For instance, someone witnessed an apparently German battalion moving along the route of the old riverside road, but cars were driving through it without any apparent awareness. Whatever force in the universe preserves these apparitions we call ghosts has plenty of business doing it in places like these. Is it a feature of the spot of ground in which they're seen or is it some other time-shifting circumstance that replays the visions?

Psychic sound effects at the park are equally dramatic. David Pitkin recounts an instance of a young witness conversing with the apparition of an old combatant. He also reports a 1997 case of reenactors startled as they camped by the approach of terrifying sound effects: urgent voices, rushing horses and dragging chains. I've actually heard it reported at other battlefields that human actions might "stir up" an earlier age. The early 1990s shooting of some high school kids set off, apparently, a psychic reaction at the Chippewa, Ontario (1814) site of the Battle of Chippewa.

Lovers parking by the big monument have sworn that they heard raging winds, screams and the sounds of battle. Phantom voices, even the sense of urgent conversations, comes to staff and tourists alike. Pitkin reports a pair of rangers surprised one October 3, an anniversary of Bemis Heights, by the preserved sounds of some emergency centuries before.

Regrettably, no one comments on the quality of the voices they hear at the Saratoga Battlefield. Accents would be conspicuous in actual voices two centuries old.

Possibly the most interesting feature of this mighty site is the persistent report of mysterious green lights. They have surfaced a number of times and are not widely associated in the public mind with Revolutionary battlefields. While a couple of them, because of their location, are linked to a famous apparition we'll discuss later, the majority of the reports make the Native American conception likely: these greenish lights could be the tools or forms of witches, doubtless using the latent psychic energy of the battle to their own nefarious ends. Have a care when you trip about this site near dark.

SARATOGA'S HAUNTED ARCHITECTURE

Power Places of the Second Kind

Architecture may be the most traditional of our arts. We have published poets, popular musicians and thriving crafters who consider it a badge of honor to be uncorrupted by education. In architecture, this can hardly fly. Every building you see done with any care at all is a hall of mirrors reflecting back to the very ancient world. Architecture is a continuum.

One of the traditional patterns I notice in architecture is a connection to supernatural folklore. Buildings constructed in certain styles attract a lot of ghost stories. The simplest skeptical explanation would be to say that the classic styles are more inspiring to the imagination. Like Dracula's castle or the Brontës' Victorian mansions, they look "spooky." The educated mystics among us might note that preindustrial societies reserved certain shapes, sites and ratios for their ceremonial structures, believing that they would be more welcoming to spiritual experience.

Any contemporary architect who works in the old styles has perpetuated, to some degree, the same effect via form. Thus, many young and spiritually unassuming buildings—homes, post offices and schools—involve traditional shapes and ratios once so invested with philosophy. It is worth pointing out that not only do ghost stories follow styles of architecture, but they can also follow individual designers, a few of whom this chapter will discuss.

We should not forget that landscape architecture and design are embodiments of power places. Europeans tend to create sublime sites by imposing geometric form onto landscape (think of Giza, Versailles, Washington, D.C., or the Salisbury Plain in England). Asians and Native Americans tend to pick spots in the landscape that already possess the desired blend of features and work them as little as needed. *Feng shui* is, in

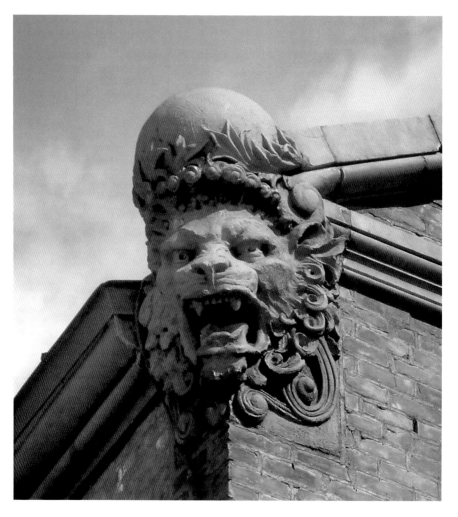

Detail of the New York State Military Museum on Lake Avenue.

part, a method of understanding landscape and applying its balance of yin and yang forces. We have reason to believe that the Native Americans of the Northeast had something like it—their own system of viewing and analyzing landscape according to its mix of smooth, hospitable features and jagged, sublime ones.

Saratoga County had, regrettably, very few of the ancient sacred monuments and enclosures so common in some other parts of New York State. Since Saratoga Springs' more recent public outdoor architecture is so dynamic, we can't avoid discussing three regions that involve powerful

psychic folklore. These, too, can be sites and places of big *orenda*, big *Manitou*. They are surely power sites of the second kind, ones that people, through their labor and devotion, have made. It is an easy reach to see how vision sites might translate into psychic reports. This tribe's devil is another's god; someone's miracle could easily be another's ghost.

Congress Park

Many of the town's most photographed structures are in Congress Park. At the northeast end, the pale tritons "Spit and Spat" spout water from their seashell trumpets. Feet away, near the corner of Circular and Spring, is the Italian Garden, with the herm busts on pillars so reminiscent of those of ancient Athens. At the center, a Doric ring of columns that juts into the little pond might be a philosophers' circle were it not a war memorial. Neoclassical painted iron urns, *Night* and *Day*, remind us of Keats's ode—or the Wedgwood designs of John Flaxman. To the south are stone stairs and landings sculpted into the hillside and a row of houses mounting the lip. At the west end by Broadway is *The Spirit of Life*, the 1914 memorial to Spencer and Katrina Trask. Its backdrop at the Columbian Spring was designed by architect Henry Bacon. The sculptor of its Greek-style diva, Daniel Chester French, did the statues of John Harvard at Harvard, the Minuteman at Concord and Honest Abe at Washington, D.C.'s Lincoln Memorial. So classic are the forms set like gems into this hollow that one would never guess Congress Park's beginnings, other than that it must have been a place of big *orenda*.

Half a mile south of Alexander Bryan's place near High Rock Springs was a wild swamp. The north-flowing stream that watered it eventually joins the Fish Kill and the Hudson, but here it was tender enough that a passerby could spot bubbles coming up from the bed. In 1792, Nicholas Gilman found another of Saratoga's famous springs. (Lest it surprise you that one might hide under flowing water, there's a geyser in a creek in Saratoga Spa State Park.) Since Gilman either was or fancied himself to be a member of the First Continental Congress, he called his discovery Congress Spring. One would have had to divert the stream, though, to make use of it.

Another big and early Saratoga name, Gideon Putnam, did just that. Putnam, the man who gave birth to Saratoga's spring industry and thus the shape of the town, is sometimes called a prophet. To capitalize on his vision, Putnam put up a Federal-style boardinghouse, possibly near the spot

The Spirit of Life at Congress Park.

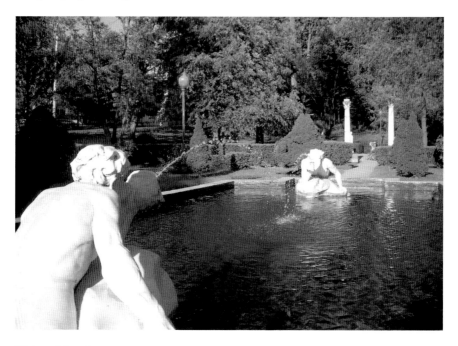

"Spit and Spat."

of today's Canfield Casino/Saratoga Springs History Museum. Putnam laid out a few streets in the area, and in 1811, he built his larger hotel at about the site of today's Saratoga Arts Center at the southeast corner of Broadway and Spring. The Grand Union was eventually the biggest hotel in the world. As the beams for it were raised, Putnam took a fall from the scaffolding and this eventually killed him. Putnam's heirs let the lease to the spring lapse. A new owner saw a bit more potential.

Aiming to give the public the European landscaped grounds that only European nobles could enjoy, Dr. John Clarke drained the swamp. He set up pleasant walkways and even a water tower in the highly symbolic form of an obelisk. (To the Egyptians, obelisks symbolized the relationship of the pharaoh to the sun god. To the Romans, the obelisks they transplanted to Rome symbolized their conquest of the Egyptians.) The tone of the park, and much of its imagery, hails from Clarke's tenancy.

By the 1870s, John Morrissey's Casino was in full bloom. By 1875, Frederick Law Olmsted (1822–1903) had been recruited to develop Congress Park even more. By 1902, Richard Canfield had bought the whole park in support of his casino, and many of the monuments we see today date from his tenure. By 1905, the Italian Garden was roughly as it is today. Unknown sculptors in Italy designed the beloved Triton twins Spit and Spat. By 1911, the City of Saratoga Springs had gained ownership of the park, and it has lovingly cared for it ever since. In 1976, the park was landscaped again. The village brook that cut the park in half was channeled underground, leaving a meditative trough in the middle.

Olmsted's touch has a strong connection to mysticism and folklore. Olmsted may be called an architect of landscape, but he is considered one of the American masters of architecture of any kind. There may be unexpected influences in his work, including a way of regarding natural features that is totally non-Western.

At the April 1998 conference of the New England Antiquities Research Association, New York filmmaker Ted Timreck presented *The Devil's Footstep*, a film and study of Olmsted's designs. In Olmsted's working of natural features, Timreck noted a balance of the "pastoral" (in the Classical sense) and the "sublime" (in the Romantic sense). It is also mighty close to a way of regarding natural features based on Iroquois and Algonquin creation myths. (The god twins often called "Good Mind" and "Bad Mind" might be best translated as "Smooth" and "Twisty.") As a young journalist and apprentice, Olmsted certainly had the opportunity to be exposed to both systems. In this scheme, sites gifted with or shaped into the ideal balance of features

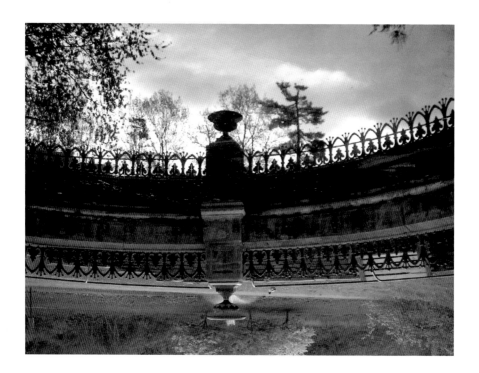

promote desired goals, possibly physical or spiritual nurturing. An unlikely balance produces a clash that can be negative or visionary.

Olmsted's designs included European systems, too. One of Olmsted's old landscape designs intended for Washington, D.C., is clearly Classical. He might have been trying to get at the cabalistic "Tree of Life" form in his Buffalo, New York parkways. Whatever we make of it, Olmsted's parks, circles and ways collect and channel "the Force," whether you call it *ch'i*, *Manitou* or *orenda*. Wherever you see his configurations, they tend to attract paranormal reports.

We have a couple fine ghost stories from the Casino at the center of Congress Park, and one might suggest that their predilection to manifest could have some relationship to their siting. Reports of the omnipresent moving mystery lights are fixtures of non-Olmstedian swamps. But this mighty park is ringed with hauntings. Even the prominent Batcheller Mansion at the park's southern lip might be considered to be within the zone of influence.

One of the portals of Saratoga Springs is Congress Park. For those who want to understand Saratoga Springs or any other message about life, art, spirit or themselves, this is one of the great places to turn aside and brood.

You are in sacred space here. You change when you come in, and you take something of it with you forever. Enter and leave knowing that.

RICHARD UPJOHN

Another influential "haunted architect" of Saratoga Springs was English-born Richard Upjohn (1802–1878). Upjohn started his career as a virtual carpenter. He came to Massachusetts as a husband and father and began distinguishing himself around Boston, designing, among other things, the Classical entrances to Boston Common. By 1839, Upjohn had moved to New York City and was on his way to an impressive career.

Upjohn designed some imposing private homes in the East and South and was noted for developing an asymmetrical Italian villa style, whose embodiments are most pleasing to look upon. He may be best known these days for his Gothic Revival churches, usually soaring, spiky, inspirational forms with a touch of the gloomy about them.

Upjohn's Saratoga Springs church is the Bethesda Episcopal on Washington Street. It is a considerable departure from most of his other fanes, being fairly light colored and close to the vest in its particulars. Squat and blocky for an Upjohn church, it's a bulldog, not a greyhound. It gives more the impression of a fort from the outside. Within the 1844 original, we could see sacred forms like the cruciform nave (the part of the church open to worshippers). There were also churchy styles distinctive to Upjohn, who was fond of expressing the concept of the Trinity in the physical form. At Bethesda, he did so using banks of threes: doors, openings and the curious stained-glass windows. (One of the glories of this church, these windows hold an odd and potentially Gnostic mix of images that includes Old and New Testament symbols and alchemical and even occult images, like the ambiguous eye in the pyramid of the American Great Seal, on the back of the dollar bill.) Above the High Altar, a stained-glass window donated in 1887 by Spencer and Katrina Trask portrays a healing miracle by a spring like one of Saratoga's from the Gospel of John. It's called *Bethesda* in the Good Book.

In short, this is a heavy building, rooted in its region. A psychic report or two might be anticipated. Besides the random and ambiguous pattern of SPOTUK, to be expected at any old and important site, we've heard of a single traditional ghost. People near the organ sense the brief form of a person in a purple windbreaker, usually a quick image at the corner of the eye. The sense is that this may not be an ancient ghost. It could be an elderly female.

Forgive me if I have no more to say about the Bethesda's ghosts—or any ghost in a church. Many churches develop ghost lore, but few are easy places to interview for it. People in positions to know the tales of a church are often quite guarded. The reasons for that could vary. The general public has a strong tendency to view anything spooky as "evil" and to think that the power of the holy in any self-respecting church would be antiseptic to anything spiritually dubious. It figures that a high percentage of people who think that way would frequent churches. While a dramatic, orthodox apparition like the Son of the Lord, or His mother, would be taken as a sign of a church's sanctity, any less-specific spook could symbolize that a church lacks the clout to keep it out. To me, a purple-suited spook or two is a sign of the power the site might truly have. At least it's not "that Shadow" I hear reported in the church that Upjohn built in Buffalo.

ISAAC PERRY

A mighty shadow falls over Saratoga Springs. It is that of a famous American "haunted architect" who may never even have been there. New Orleans–born Henry Hobson Richardson (1838–1886) founded an American style so distinctive that it bears his name: Richardsonian Romanesque. Richardson's designs are original enough in places to be shocking. Trinity Church in Boston, Massachusetts, is a visual journey. One wonders that anyone was allowed to make it. The administration building of the New York State Asylum in Buffalo, New York, is similar, and, incidentally, it is outrageously haunted. Even Richardson replica buildings have ghost stories—like a 1911 train station in Orchard Park, New York, that merely imitates Richardson's original in Auburndale, Massachusetts. It should be no shock that those he tutored perpetuate his influence.

It wasn't unusual in Richardson's Victorian prime for American architects to imitate medieval European buildings, typically churches and castles. It was, in fact, a fixture of the Arts and Crafts Movement so in vogue in the day to reject overt classical (Greek and Roman) influences and pursue those of the European Middle Ages. Still, Richardson did something unique, adapting a very medieval form into popular use in American cities. Some of Saratoga Springs' most prominent buildings show Richardsonian style.

Richardson had many disciples and admirers, among them the prolific New York State architect Isaac Perry (1822–1904). Perry was

The New York State Military Museum on Lake Avenue.

a Vermonter transplanted as a boy to Keesville, New York, where, like his someday employer Richard Upjohn, he started in woodwork with his shipwright/carpenter father Seneca Perry. Young Isaac displayed a flair for spiral staircases. By 1852, he had moved to New York and was apprenticing under Thomas R. Jackson (1826–1901), head draftsman in Upjohn's firm.

Isaac Perry took over Richardson's work at the capitol in Albany after Richardson's untimely death. This spectacular building has experienced myriad accidents and disasters, including the 1911 fire that destroyed many Native American artifacts and took the life of at least one watchman, who may come back as a well-known ghost. Even that fire has occult rumors, being attributed to the anger of some Mohawk false face masks that were "tired" of being mistreated.

Perry specialized in mammoth, powerful buildings. Unless your name happens to be Frankenstein, you might not think of Perry first to build your

house. Perry is known most for designing asylums and armories across New York State. His relevance to Saratoga Springs is the 1889 National Guard Armory, right across Lake Avenue from Gifford Slocum's haunted fire hall.

By the mid-1800s, the U.S. government had learned a couple of lessons. One was that it needed a spread-out network of strong, safe places to keep military-style weapons and ammunition. Domestic wars, like the Revolution or the Civil War, tended to break out and be fought virtually everywhere. Perry was a natural for designing these strong monuments. If the *Night of the Living Dead* ever came to pass for real, these armories would be valuable again.

One wonders why a fortress should be so pleasing to look at. The ruddy spectacle on Lake Avenue originally had round towers with candle-snuffer tops. These were replaced in 1905 with the crenellated—square zigzag—parapets that were so useful for shooting arrows from the medieval fort. Elegant and angry stone lion heads snarl outward as if part of the building itself could lunge against an attacker.

Think about the Perry buildings—asylums and armories. Apart from the fact that the nineteenth-century ones that still stand tend to attract ghost stories, the human profiles of these two buildings are radically different.

Old hospitals and asylums are ominous and tragic places in the popular imagination. Ostensibly places where healing took place, their main service was to keep the people inside from getting out. They were virtual prisons, behind whose looming walls many tragic, confused, despair-ridden deaths took place. The psychic residue should be chaotic.

Armories were meant to keep people on the outside from getting in. As places from which military power ventured outward, they can hold an almost religious sanctity today. Armories were the home bases of military units, from which men marched off to war. Not all returned, and these armories can be sites where their sacrifices are commemorated with mementoes and ceremonies. They can even be virtual social clubs where surviving veterans associate. No wonder, for those who remember, this site is a hall of reflection for many veterans from Saratoga Springs and Saratoga County.

Today, the armory on Lake Avenue is the New York State Military Museum, a fine place to do specialized research. There is some amorphous psychic lore about it that includes reports of a phantom drill troop in the back (north) side of the building and other minor physical effects common to libraries. If people weren't so used to the pattern by now—or if this were the one haunted building in town—the former armory might be a local legend. So far, there are no reports of a single famous ghost. Some rumors about the building may be inextricable from a tragic accident at the train station. As

the Saratoga troop pulled out to head to World War II, two young girls from Saratoga Springs High School were killed. In other times, and in different world societies, this would be seen as a sign that the gods either blessed the undertaking with sacrifice or cursed it with disaster.

S. GIFFORD SLOCUM

If H.H. Richardson casts a mighty shadow on American architecture, it was S. Gifford Slocum (1854–1920) who positioned it to fall on Saratoga. Samuel Gifford Slocum was born in LeRay, Jefferson County, New York. From 1873 to 1875, he studied architecture at Cornell University under the influential Charles Babcock. An author and teacher, Babcock was himself a disciple of Richard Upjohn, and Slocum was Babcock's acolyte—so to the hilt that he married Babcock's daughter. Slocum settled in a number of different communities, including Canandaigua and Saratoga Springs. He had offices, too, in nearby Glens Falls. Slocum not only practiced architecture, but also—true to the period and to the Arts and Crafts Movement ideals—pursued a number of other arts, including painting, furniture design, sculpture, wood carving and teaching.

While one commenter stereotypes Gifford Slocum as a designer of Queen Anne–style homes for high-rolling clients—a virtual "foo-foo" architect—it should not be forgotten that Slocum wrought the imposing, innovative Richardsonian Romanesque Algonquin, to be discussed on its own. Three special sites around the village bearing Slocum's mark are thought to be haunted, and one wonders if they all might not have some rumor or other associated with them, merely unrecorded as yet.

Greenfield Avenue is a little road west of Broadway, just south of the new Skidmore Campus, and it hosts one of Slocum's more interesting sites. Number 22 Greenfield was once the home of Slocum himself, but he seems to have spent very little time there. Village mayor Walter Prentiss Butler took it over and held it for many years. This fellow took advantage of the early twentieth-century shortage of hotel space and rented it out to some legendary characters, including "Diamond" Jim Brady and his longtime paramour, actress Lillian Russell. Author David Pitkin considers the most likely ghost here to be the late Mayor Butler. He was the only one known to have died here.

The 1884 firehouse at 543 Broadway has been many things since its early days, including a series of restaurants. Every time I did interviews at the site,

The Old Fire House on Broadway.

each new squad of occupants had its reports. The folks who used to work at one restaurant incarnation spoke of phantom diners and images of "extra" people coming down stairs that aren't there any more—something like what we hear about at the Olde Bryan Inn. Other reports tended to involve the all-too-familiar SPOTUK—sounds and physical effects—and the occasional impression of some phantom flashing shape right about where the fire pole would have been. I find it funny that when I did interviews in 2003 and the building was split up into two businesses, neither enterprise thought its place was haunted, but both were sure the other was. ("Don't tell them. They wouldn't want to know.")

Other Slocum sites about Saratoga Springs include a couple of mansions on Clinton Street and a pair on North Broadway, as well as the Granite

Palace (348–358 Broadway). I lived in a Slocum site on one of my Saratoga stays, a charming home at 107 Union Avenue that had been turned into apartments. I should have paid a bit more attention to some of the sound effects that I attributed to the creaks and groans of an old building. Other sites attributed to Slocum are the fire hall on Lake Avenue and the Lake Avenue school, both with their own supernatural stories.

It has been conjectured that Mormon founder Joseph Smith was influenced by his childhood in mid-state Vermont, a zone of strange ancient stonework. Gifford Slocum may have lived near Canandaigua Lake, a region of ancient monuments and the Great Hill of Seneca creation. One wonders if he could have been affected.

Spas and SPAC

The mineral waters in and around Saratoga Springs healed Native Americans for centuries. They supported a thriving resort community all through the 1800s. By the early twentieth century, the national soda fountain industry needed fizz, of which there was plenty in Saratoga's water. Commercial interests ended up drilling over two hundred wells and endangered the local water table. They showed no sign of stopping for green or civic concerns. In 1912, New York State took over four hundred acres southwest of the village, capped the wells and gave things a chance to recover. "By 1913," wrote James Kettlewell, "New York State was in the bath and spring business." This is one instance in which government takeover was a good thing. We would not have otherwise had the lovely park.

Then state governor Franklin D. Roosevelt hired an architect to model Saratoga Spa State Park after the spas in Europe, hence the many Classical features we see there today. The park operated as a healing spa and health community based on four-week stays. Soon, it needed a hotel. Named for the prominent early Saratogian, today's Gideon Putnam is open to the public year-round. By 1935, most of today's park buildings were in place.

In 2009, this is a twenty-two-hundred-acre cultural and recreational paradise. It has wooded trails, parkways and open spaces. People golf, bike, run, ski and play tennis here. The park's two theatres and outdoor show grounds host performing arts ranging from drama, ballet and classical music to rock concerts. The healing industry is in fine form, too. The baths and spa are still here.

One thing about this park that will impress the first-timer is its mix of highly formal, European-style architecture and natural northeastern landscape. Hills, creeks and trees—evergreens and maples—mix smoothly with columns and colonnades. This is what I call the Saratoga style, a Euro mix on northeastern earth, measured architectural formality that clashes sublimely with the terrain.

One of the park's Colonial-style buildings is the Gideon Putnam Hotel. Others are outright Classical, including colonnades, façades and statues. One marked departure is the former Washington Bathhouse, designed by Lewis F. Pilcher in 1918, today's National Museum of Dance and Hall of Fame. It is done in a Craftsman/Bungalow style that suggests the Arts and Crafts leanings of Frank Lloyd Wright's early sites.

Not only the buildings are sculpted. Landscape architect A.F. Brinkerhoff's design for the northern section of the park, just south of the Avenue of the Pines, includes long malls, reflecting pools and tree-shaded avenues. Its formal, almost cruciform shape reminds one quite strongly of Versailles and the Louvre in France. One wonders if its processionals—designs people can walk—might not make the same statement as the Nasca lines in Peru, merely more geometrical and less organic. While only this part of the Spa State Park was landscaped as

deliberately as Congress Park or Yaddo, the collective beauty and natural energy of the whole site are tremendous. I am not surprised that it features many zones of psychic reports.

A few of the park rangers admit that poltergeist-style phenomena take place in the building they occupy, the Lincoln Baths. This marvelously Classical structure designed by William E. Haugaard was completed in 1930 after an original structure there burned to the ground. The veteran officers always give the "newbies" the heads up that the building is haunted. What I've heard so far are merely random physical effects—SPOTUK—but they still spook the general public.

The former Bottling Plant—a Colonial-style 1935 building—houses the Auto Museum today. Those who work in and around it have a few tales of undramatic physical phenomena and dim apparitions, some of them outside at a nearby spring.

Apparitions of unspecified types are reported near a number of the springs. From the lack of detail in the reports I've heard, I judge that the forms may be indistinct, as if the spring itself could be an optical-effects generator, possibly a gateway to a realm of altered perception. Springs and fountains were considered so in the ancient world.

There are either several "Woman in White" apparitions or the same energetic one reported about the park. If any one of these had a clear association with one of these springs, some people might take this as a Marian apparition, a whole different scenario in a lot of ways.

All theatres attract ghost stories—at least ones that, in the motif, hope to survive. (A theatre without a ghost is considered cursed.) We should not be surprised that the Spa Little Theatre housed in the glorious Classical-style Administration Building has its tales, many of which David Pitkin ably recounts in *Ghosts of the Northeast* (2002). The haunter, Pitkin conjectures, could well be character actor and longtime Saratoga Springs resident Monty Wooley (1888–1974), who performed there many times. It's either "the Beard" (as Wooley was called) or John Houseman (1902–1988), after whom the Little Theatre was briefly named.

One effect I have experienced personally at the park is the impression that slow-moving hikers have been miraculously transported across distance. On two occasions in the spring and summer of 2009, I spotted a pedestrian distinctive in dress or shape and built more for comfort than for speed. I met him again in another part of the park a long distance away. I knew I was moving a lot faster, and for him to pop out of the trees and show himself the way he did was curious. Of course, I attribute my experience to imagination.

I wouldn't even include it in a piece on the paranormal if I hadn't heard of others reporting the same effect.

There is a lot of energy of the man-made variety at Saratoga Performing Arts Center as well. While James Kettlewell wryly calls its sustaining outdoor amphitheatre a kind of "permanent Woodstock," one can't fail to observe that against the stately backdrop of the park's architecture and green space, some outwardly rebellious music takes the stage. This is quite a clash—one that does nothing but add to the experience.

YADDO

Judging by the legends and vision tales associated with the site of today's Yaddo, it was power ground long before Spencer and Katrina Trask set up their estate at the foot of Union Avenue at the backstretch of today's famed Saratoga Race Course.

Easy to reach by canoe in the old days, this wet, wooded, four-hundred-acre tract at the edge of Bear Swamp was treasured camping, fishing and hunting ground to the Native Americans. It may even have been a holy ground and battlefield. (The European mind has trouble sometimes with things being strongly one quality and also another that seems divergent. The

Native American mind does not.) There could have been many turf fights at Yaddo between Algonquin-speaking nations like the Mahicans and the warlike Iroquoian Mohawks. Out of one of these fights comes an old tale of a miraculous ghost—a woman's apparition rising from one of the small lakes.

By 1784, the site of today's Yaddo on the ancient route to Saratoga Lake (now Union Avenue) was most likely the land of Jacob Barhyte. His two mills working grain and lumber were the motor that drove the enterprise, though he had a farm and an inn that served the region's best trout dinner. The trick was to catch the main course yourself, sort of a "You hook 'em, we cook 'em," arrangement. The Barhytes' guests included Baron Von Steuben, Alexander Hamilton, George Washington and a moody young man who signed in as Edgar Allan Poe. There is even a rumor that Poe may have written his gloomy raven verse about the pre-Yaddo grounds and that he sometimes surfaces as a ghost. This would certainly have been a good place to write, even without today's art and engineering. Only a strip mall could take the atmosphere out of those ponds, creeks and pines.

By 1840, Edward Childs and his doctor son, Richard, set their impressive Italian villa right where today's mansion stands. By 1871, it was unoccupied and remained so for ten years. Surely, psychic folklore developed during this period.

The Spencer and Katrina Trask Mansion.

Financier and philanthropist Spencer Trask (1844–1909) started rehabbing Childs's mansion in 1881. His wife, Katrina Nichols Trask (1853–1922), was illustrious herself as a poet, author and peace activist. In 1889, while walking the visionary grounds, Katrina had the inspiration she considered psychic—that of turning the estate into a perpetual conference of writers, artists and composers. When fire struck the Trask/Childs manse in 1891, the Yaddo of Katrina's vision started to take form.

Though William Halsey Wood is credited as Yaddo's architect, it seems that the Trasks designed it themselves, inspired by Haddon Hall in Derbyshire, England. The Yaddo grounds feature stately gardens and paths of the European style. Statues of goddesses embody the seasons and display four-quarters symbolism. The Classical rose garden may represent Apollonian reason; a fountain formed in rough, megalithic-style rocks symbolizes Dionysian intuition. The statue of a ringleted hero in the pines at today's Yaddo stands for Katrina Trask's most memorable character, the hero of *Christalan*, a fairly long, antique poem published in 1903. Her hero's name is made from that of two Trask children, Christina and Alanson.

There was also reconfiguration of the natural land that could have been influenced by the Native American system Katrina Trask so admired. A new causeway cut Barhyte's lake into two, and two other small ponds were made. The four were named for the Trask children, as if a family etched itself onto the landscape. I concur with James Kettlewell: there is much more to be read here than has been interpreted so far.

On New Year's Eve 1909, Spencer Trask was killed when his homeward-bound train was rear-ended. In 1919, Katrina Trask married again, at Yaddo, and lived just another year. Through her bequest, Yaddo was a gift to the world. Today, the Trask Mansion at Yaddo is an artist's retreat graced with the visits of many prominent people. Since its inception in 1900, Yaddo has hosted sixty Pulitzer Prize–winning authors and one winner of the Nobel Prize. Sylvia Plath, Truman Capote and David Sedaris are among the artists in residence.

With all of that history and legacy—and the hotbed any human community is for gossip—it figures that there are ghost stories at Yaddo. Circumstances do not disappoint. Upstate journalist/folklorist Carl Carmer (1893–1976) noted that some of his Yaddo fellows were aware of ghosts. One of them seemed shocked by the sight of the colonial-era ghosts of a dark-haired woman and a red-coated man arguing by one of Yaddo's lakes. We must not forget the sighting of what was considered Poe's ghost, mentioned earlier. More recent Yaddo residents visit the village during their stays and tell many Saratogians their tales. A late 1990s Yaddo guest told a clerk at Lyrical Ballads bookstore about a Victorian woman ghost he saw once in his own room.

David Pitkin's books recount tales of strange and potentially psychic physical phenomena, as well as a longstanding tradition among the Saratoga Springs police that the place could be spooked. Other traditions at Yaddo include the rumor that the Victorian-style "Woman in White"

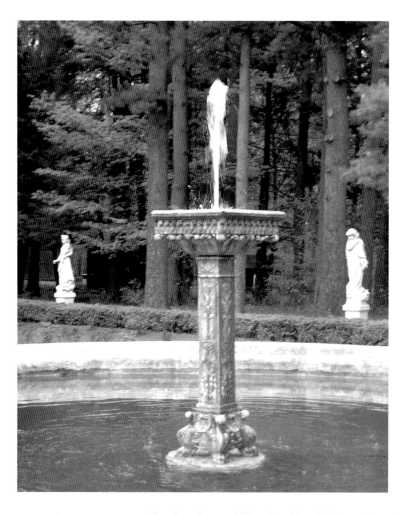

that so many encounter may be the ghost of Katrina Trask. Some longtime Yaddoans conjecture, however, that just as likely a spook is Elizabeth Ames (1885–1977), a steel-backboned caretaker and manager once accused of communist leanings.

Today, most of Yaddo's glorious gardens and grounds are open to the public year-round. If you arrive after September but before mid-May, you shouldn't expect to see the statues uncovered, the roses blooming or the fountains beaming, but at those "off" times of year it could be, like Lily Dale, even more sublime. For all those in the world who capture orbs and EVPs at haunted buildings—surely many who take pictures here catch *something*. Photographer Michael Noonan was one of them. His beloved late dog Tudd took one of those hard stares into the dusky air, and Michael snapped a

shot in that direction. When it was developed, a curious, indistinct form appeared, one that had been invisible to the human eye at the time.

Ink has been spilled and words have circulated over the source of the name *Yaddo*. One common explanation is that young Christina Trask came in from her play talking about this or that "Yaddo." While this has been interpreted as a four-year-old's way of saying "shadow," other speculation abounds. Imaginary friends and inaudible dialogues are so common among young children, particularly at haunted sites, that one's feelers perk up at the suggestion. Her acquaintance-about-the-grounds' name was "like shadow," she said. But "shadow" wouldn't do, since whatever it was was "bright and not dark." There's some talk that, unbeknownst to any of them at the time, there was an Old English word that would have sounded quite like "yaddo," one that meant "to shimmer," as light would upon the surface of the ponds. Maybe this accounts for the phantom children's laughter that some people I know have reported hearing as twilight settles on Yaddo.

Speaking of the Trask children reminds one that wealth and success protect no one from tragedy—none of the four lived into their teens. The causes of their deaths were not mysterious. It was an age in which child mortality was lamentably high, and few epidemics were controllable. Two Trask children were permitted to give a last kiss to their mother, who was

presumably dying of diphtheria. Instead, it was they who were gone within days. Still, this hasn't stopped talk of some ominous bogie at the grounds, possibly some kind of child-killing karma, that wouldn't stop until it ran its course. It would be interesting to know what the sounds of the word *Yaddo* meant in the native tongues, or who or what the doomed Christina met in the trees that spoke to her in a dead language.

Spa City Sites

Spa City Spooks

If there is one thing we think we know about ghosts, it is that they are site specific. Except for the ghosts of famous people (which could quite well be folkloric), the same ghost is almost never reliably reported in more than one place. In that regard, these apparitions we call ghosts are shockingly localized.

There are countless sites in the city of Saratoga Springs and immediate region that attract long patterns of ghost stories. The same stories are recycled innumerable times in newspaper and magazine accounts, starting at least in the last half of the twentieth century. The region is quite folkloric, if not also haunted. Someone who would like to read accounts of a great variety of sites might turn to the books of David Pitkin, particularly *Haunted Saratoga County* (2005). What I have included here is my list of the most prominent sites in the city of Saratoga. These are ones you can visit, tour and even spend a night in. Some of them have been done to death in earlier accounts and there is little left to say. But you can't do a book on the haunted sites of Saratoga Springs and leave out the most prominent haunted sites. Here are my top ten.

THE OLDE BRYAN INN

One of Saratoga Springs' two most famous haunts is at a power position, at the lip of the fault on Maple Street and just uphill from the legendary High

The Olde Bryan Inn.

Rock Springs. We've seen already that these springs were the impetus for the first white settlement in Saratoga. A log cabin on the bluff overlooking the springs was an inn as early as 1773, but the Revolution stirred everybody up. Not much lasting was made of this first endeavor.

When things quieted down, General Phillip Schuyler routed his log road from Schuylerville to the springs in Saratoga. By 1783, he and his family had become accustomed to weeks-long camping vacations here. George Washington, Alexander Hamilton and New York governor Dewitt Clinton visited the High Rock Springs when they came to see General Schuyler and tour the Stillwater battlefield. Most likely, they stayed in General Schuyler's tent. George Washington was so inspired by the springs that he even tried to buy the land. Others held the title, however, and they weren't interested in parting with it.

Schuyler set up a two-room home where he summered for the rest of his life. By 1787, an inn on the site had been sold to Revolutionary War hero Alexander Bryan, who put up a blacksmith shop and another log house across the street, which he operated as a tavern and inn until the turn of the century.

This Alexander Bryan—the first permanent white resident of Saratoga Springs—was quite the character. A convivial Irish-American innkeeper before the war commenced, Bryan had friends and former patrons on both sides, and—possibly bearing a barrel of booze—he found it easy to fall in with the British army of Gentleman Johnny in the early fall of 1777. He gained some information that would help the Revolutionary cause at the Stillwater battle, but his cover was blown, and he had to hoof it for days. At the direst point, he may have escaped capture by hiding for quite some time in a river with only his open mouth above water for breathing. (I'm told that there is no truth to the rumor that a sympathetic fellow spy fortified him by pouring whiskey down his throat.)

Until 1801, the only inn in town was the one Bryan opened. At that time, Gideon Putnam put up the famous Grand Union. In 1832, John Bryan built a stone house on the site of his father's tavern. This is probably the date of the oldest part of the building we see today. It remained in the family as a home until the twentieth century.

In 1925, what we call the Olde Bryan got a brick addition, and Burnham's Hand Laundry started up. It was a memorable operation for many guests and visitors to Saratoga Springs. In 1954, the Veitch family bought the place and lived in it as a home. In 1979, Dave Powers and Joe Wilkinson took over the site with the intent to restore it as an inn. Steve Sullivan joined the partnership in 1981, and the Olde Bryan took the form we see today. (Maestro Powers has a knack for getting involved with haunted Saratoga restaurants. With Steve Sullivan, he opened up Longfellows Inn and Restaurant on Saratoga Lake in 1996. It was a tough call to leave Longfellows out of this book.)

Today "the OBI," as the locals call it, treasures its ghost stories and encounters of other psychic types. It has a couple of hot zones for psychic effects, too, including the second-floor bathrooms and the big first-floor dining area. It is most dramatic for its apparitions—ghosts. We thank David Pitkin's books and the OBI website write-up of Nathan York for a number of reports, including:

- A Revolutionary-era soldier in today's dining room area.
- A colonial-era horse and rider apparition—in the bathroom—carrying a lance.
- The persistent apparitions of a woman in a long, old-time green dress.
- A mirror in which the image of an older woman manifests behind the observer.
- SPOTUK effects involving self-operating lights.

- SPOTUK effects involving a strangely swinging chandelier.
- SPOTUK effects of an occasional, reassuring touch, in many parts of the building.

This woman in green has been appearing for decades, and she may be the OBI's most interesting ghost. They call her Eleanor. One story about her comes from a server, who observed a child who wouldn't climb the stairs with her grandmother because a woman in a green dress was in the way. Children are widely thought to be more psychic than adults, and they may see things we do not.

Psychic adults go out for dinner, too, and the occasional such guest of the OBI claims to spot this figure in spirit form, often telling the tale to a server. According to a member of the Veitch family, a garment similar to the familiar green dress was in the possession of his grandmother, Beatrice Veitch. She may be the likeliest candidate for the apparition. But as is so commonly the case, the question of a ghost's identity may not have such an easy answer. The same ghost was reported decades earlier, unrecognized, by a young woman who would have known Mrs. Veitch. This form, incidentally, has been reported walking a slanting course in the air of the dining room, as if using an invisible stairway that once existed in the very spot.

The colonial-era horseman with the lance may not be so out of place—if you can get by its appearance in the bathroom. Many officers of both the British and Continental armies led their men into battle using *spontoons*, virtual spears, often fancy headed. This baton of authority was also a nifty weapon if the fighting came to close quarters.

It is hard to claim that there is nothing psychic going on at a place like the Olde Bryan Inn, but it's all pretty lighthearted, merely curious. You will enjoy your visit there. Be ready for a couple of stories.

PALACE OF PLEASURE

The second half of the nineteenth century tends to be called Saratoga's "Golden Age." It was one of the dominant resorts of the eastern United States during that time. A lot of the fast life and glamour of the Victorian world passed through here. But author Henry James was unimpressed, noting that much of Saratoga Springs' apparent splendor was skin deep. James Kettlewell even remarked that the age should be called "gilded" rather than "golden." By the 1870s and 1880s, most old money had gone to

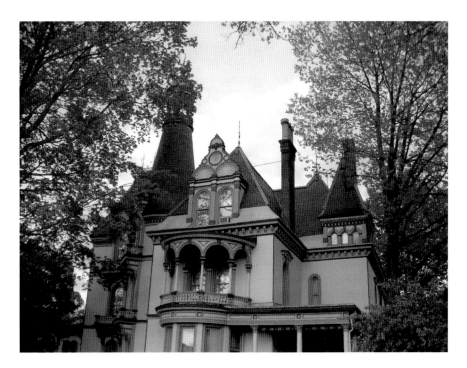

The Batcheller Mansion.

Newport. Saratoga Springs was the realm of the new. If there is a symbol of something showy and representative of the period, the Batcheller Mansion ought to be it. Saratoga Springs' other most famous haunt could be the most photographed private residence in the city.

First owner and builder George Sherman Batcheller (1837–1908) was a precocious achiever. He was elected to the New York State Assembly as a twenty-two-year-old. A brave and successful Civil War general, Batcheller went on to a life of public service. Willing to "take one for the team," Batcheller had a knack for getting assigned to things he found uncongenial. He was appointed assistant secretary of the treasury because there was a gap. He was appointed minister resident and consul general to Portugal when his familiarity with Arabic and Turkic people should have sent him somewhere else. General George always considered Saratoga Springs his home. He rests with his wife, Catharine Philips Cook Batcheller, under an Egyptian monument, with "winged-sun" motif over the lintel, in Greenridge Cemetery, rooted no less firmly than his grand mansion in the climate and mystery of his town.

Ink has been spilled over the inspiration for the much-admired Batcheller Mansion, constructed in 1873 by the Albany architectural firm of Charles C. Nichols and John B. Halcott. The Batcheller shows features of the high Victorian Gothic style reminiscent of some spectacular medieval castles. But there are other influences behind this astonishing mansion at 20 Circular Street.

Many think that the Albany capitol building designed by H.H. Richardson could have been an inspiration. General George spent a lot of time there. Victorian architecture typically lifts from earlier styles, and Victorian architects tried for originality in putting the features together. But the Batcheller would hardly stand out in Saratoga Springs as one more Victorian.

What grabs everyone's attention at the Batcheller are its Middle Eastern overtones. James Kettlewell remarks on the conical tower with its "minaret-like termination." Stephen Prokopoff and Joan Siegfried conjecture that the design may have corresponded to a short-lived trend in American architecture called Moorish Revival. That would figure. George Batcheller served on the international tribunal for the administration of Egypt. He and his family lived ten years in Cairo and would have been exposed to a lot of Moorish architecture. The Batcheller even has an Arabic name—*Kasr-el-Nouzia*—which I hear may mean "Palace of Pleasure." This whiff of Islam predated Batcheller's actual Egyptian service. He may have wrought his mansion to commemorate his appointment.

Like many of New York State's architectural treasures, the Batcheller has gone through multiple uses—hotels and retirement homes—and cycles of abandonment. One three-year vacancy started in 1937. The worst and longest was from 1966 to 1973, when an absentee owner allowed it to become a local scourge, a home for vagrants and a target for vandals. A couple of shining-armor knights came through and rehabbed the Batcheller, which today is a splendid bed-and-breakfast, one I hope thrives for many centuries. These periods of neglect never hurt a site's psychic allure, and doubtless this was the beginning of at least the contemporary cycle.

When it comes to psychic rumors, the Batcheller is another one of those Saratoga sites whose reputation precedes it. Endlessly mentioned as a haunt in print and in public, the Batcheller cannot be left out of any haunted work. It may not even be *that* haunted. It seems to lack, for instance, a single famous ghost; indeed, it may not have any at all.

The public might expect to see a ghost at a site labeled "haunted;" but it will readily perpetuate the term about a building if it merely hears reports or experiences of apparently supernatural physical phenomena. No one needs

to see a ghost, and in this sense, impression lives up to definition. If psychic phenomena were money, then to say that a building is haunted means that it is rich. From the sound of things, the Batcheller has been affluent for quite some time.

There are decades of reports of SPOTUK, the random and generally undramatic physical phenomena that, after you hear about them as much as I do in a year, can be quite boring to detail. The reader may imagine them coming to most of the five senses: the footfalls of invisible walkers, electrical tricks in lights and appliances, cold drafts of air, whiffs and wafts of perfumes and colognes. The commonly reported sense of "being watched" might be more valid as evidence of psychic phenomena than many people would presume. Tests have shown that people have a sort of ESP that tells them when someone is watching them.

In fact, the only potential report of a ghost—an apparition—is one that author David Pitkin experienced and recorded in his book *Haunted Saratoga County* (2005). It was the image of a man in the dining room in an outfit that was clearly of another day.

A number of other standout features at the Batcheller seem at least associated with latent psychic energy. James Kettlewell notes the intriguing positioning of the home. It juts aggressively forward on a small tract at the convergence of two streets. Not only does it have little privacy, but all traffic on this side of the park is drawn to it. My *feng shui* student friends would have something to say about this flow of earthly and human *ch'i*. The Batcheller also broods over Congress Park as a church might, rising in the distance as one walks and climbs to the south.

One image I can't get out of my head is of the splendid dress that Catharine Batcheller had made for a gathering in her home. Still in the collection of the Saratoga Springs Historical Society, this emerald-hued affair cost five thousand of the day's smackers, more than many families of the era made in a lifetime. That ball in the Batcheller, hosting foreign diplomats, was the grandest of 1890 in Saratoga Springs and could quite well have been the peak evening of several social careers. Surely these epiphanic moments have to leave some kind of fallout. If anyone ever reports images of Victorian ghosts at the Batcheller, I would look no further than this single, outrageous, splendorous affair—or to that dress, on a stand in the Saratoga Springs Historical Museum. The woman who wore it a single time went to her grave telling no one her true age; "?–1903" reads her Egyptian-style stone.

THE SAVAGE HOUSE

None of the authorities I have consulted name an architect for James Savage's grand 1843 Greek Revival home at 108 Circular Street. That in itself isn't mysterious. A lot of American buildings of the day were modeled almost exactly on books and design kits. The Savage House's grand colonnade—a ground-to-roof columned porch—was probably added in the 1870s, and it gives the fine building a southern plantation-era feel.

The Savage House started as a beautiful private residence. First owner James Savage owned a hardware business and bought a half interest in Congress Hall in 1856. Since then, it has been residences, hotels, boardinghouses, and apartments. It has been called the Savage House, the Isbell Home, the Ro-Ed Hotel and the Hilwin Hotel, among other things. It was a hotel until 1964. It may have been the short-lived quarters of the Saratoga Arts Workshop, a not-for-profit music and performing arts society, in the 1970s. It has also done spells as a deteriorating wreck. Doubtless, many homeless have spent nights in its moody gloom. One can only guess at their perceptions as the moonlight filtered through the branches outside and cast the shadows of the columns into the drafty space.

Its days as the Isbell Home may have been its heyday and perhaps the most likely time to have left a psychic legacy. Many famous folks came here during the Roaring Twenties and desperate 1930s. Al Jolsen, Fay Wray, Sophie Tucker and many Metropolitan Opera stars were guests. The food was so good here, they say, that Al Jolsen—at the time America's highest-paid entertainer—used to send a car from his home in Lake George to pick up dinner.

These neighborhood "wrecks" often get the reputation of being haunted, but this one has kept its aura since its restoration. Saratoga Springs is full of twenty- to forty-somethings living in apartments. Number 108 Circular Street is one of the sites that comes up a lot in interviews around town. It was mentioned in a *Poor Richard's Saratoga Journal* article of October 1990, as well as in the books of David Pitkin. Architectural historian James Kettlewell noted the proliferation of ghostly tales about this site. There seem to be several cycles.

In village rumor, a man killed his wife's boyfriend on the second floor, and the "spirit" of the lover roams the halls. In defense of this all-too-Hollywood tale, there is a story going around that someone found a gun and a bloody rag hidden in the house decades after the alleged incident. And the scenario combining hot tempers, violent emotion and ready amour could not have

The Savage House.

been new to Saratoga Springs, which was, from its inception, a place of both fast living and intrigue.

Psychic sound effects may be most common on the second and third floors. The reports I've heard are fairly generic: heavy footsteps and slamming doors. They have been reported for almost a century, though.

Spectral red birds have been reported in the Savage House, too. This ectoplasmic avian is a very rare ghostly form. The animal ghosts I hear about are almost exclusively domestic dogs, cats and horses. There are no ghostly gerbils or phantom ferrets. There could be historical support of this impression at the Savage, however. In the early 1900s, Elisha Isbell kept an aviary with a number of birds. One night, lots of them got out, and they were flocking all over the house. One wonders if some reported sounds and apparitions could be the psychic echoes of Isbell and his daughters trying to corral the birds.

There is talk about an odd wrought-iron fence here. Its effect seemed to be cumulative. It was merely warm during the day, but by ten o'clock on some nights it was too hot to hold on to. This is curious. It is hard to believe

something on this shady street could get so much sun that it would stay hot to the touch when the sun goes down. Many people examined this fence and could make no sense out of the reports. A 1974 Skidmore folklore survey found people telling stories about the psychically heated fence, as well as tales of furniture moving spontaneously within this site.

Abenaki author Joe Bruchac has a good story about 108 Circular. His sister, Marge, was in the Saratoga High School drama club, and one of her fellow actors was the son of a real estate agent. They pulled a couple strings and held a costume party in this house, which had been empty and dilapidated for some time. As the kids had their party, all of them were shocked to see themselves joined by people they didn't know in period costumes. Occasionally, some of them even followed the non–high school strangers, who always took a turn or otherwise miraculously avoided them before a conversation could begin. When the group conferred a few days later to match impressions, they were sure they had been seeing ghosts. It was as though, like gunshots and reenactors reviving the sights and sounds of a phantom battle, the partiers had summoned up guests.

I hope the afterlife isn't so boring that, once out of nature, my disembodied spirit goes around crashing high school parties. If that's the sum of it, I think I'd "jump the life to come" with Macbeth if given greatness here or even go along with Thoreau's offer to trade the prospects of the other side for a glass of cold beer on this one.

THE SHOCKER ON BROADWAY

The 300 block on the west side of Broadway features two distinctive, fairly similar neighboring buildings, both longtime hotels: the Rip Van Dam and the Adelphi at 365 Broadway. Both were constructed in 1873, and both feature a similar look, dominated by *that porch*. (That "Saratoga"-style porch, beginning at the second story and extending the whole width of the building, has been called "a remarkably original architectural vision.") Both buildings have their ghost stories, but the exquisite Adelphi is the one we'll discuss here.

The Italianate Adelphi is a fine hotel open generally five months of the year (May through October). It is also one of the town's classic haunts, despite the fact that it may never have been written up in a book or paper. I wish it had. It would have made my job a lot easier. A place this size and age has had a lot of employees, and many of them are still around.

They tell everyone in town that the place is haunted. Except for the fact that the ghosts and experiences are all peaceful and nonthreatening, they make the cavernous Adelphi sound like Dracula's Castle on one of those long winter spells.

There have been reports of the persistent physical effects of such a familiar sort that they may be imagined. Now and then, one is dramatic and so apparently pointless that the safest explanation is to say that something strange has happened. For example, one former employee reported finding that all the light bulbs from the second floor had been taken down from the twelve-foot ceiling fixtures and piled neatly on a table in the hall. This had been done since his last visit to the floor, within a half hour. While it might have been possible for a living mortal—with a ladder and motivation—to have done such a feat in the time provided, who would have bothered?

There are reports of accidental photographic effects, too. Within recent memory, some photos were taken for a promotional brochure. Some of them could not be used because of "extra" images that kept turning up, particularly in a couple of fourth-floor rooms. Some of the time they were getting "orbs," those light spheres that show up occasionally on film and are made so much of by surveillance ghost hunters. Some of the time, they were getting images that were very different: faint parts of human images—limbs, profiles—as if some sort of crazy image generator were at play, or perhaps the cameras were catching stray parts of scenes from the actual past. I am told that there was no explanation. No one besides the photographic crew was in the room.

The one ghost report I have heard circulates in the folklore of the staff of the building and the town. It is the repeated mention of a frightening ghost encountered now and then in the basement. It is a woman's image, probably from the late nineteenth century, but her face is so ugly that it is horrific. It's hard for startled and terrified witnesses to sort out if this is the apparition of a disfigured person or some sort of demon. Some members of the staff are so afraid of the basement that they refuse to enter it. There is town folklore about a longtime staffer at the hotel who had been disfigured in a fire, but I don't know if this could be a fact supporting the sighting or a story developed later. We often find folkloric "explanations" for ghosts that have no basis in traceable fact.

I almost hesitate to mention this tale about such a splendid old hotel. The Adelphi has one of the loveliest courtyard pubs you will ever see. On the right summer night, it is lush. In the off months, the long late falls, winters

and early springs, the Adelphi is atmospheric. I don't remember a single report that didn't come from one of these periods. As far as I know, the scary apparition hasn't been reported in twenty years, and I never met the eyewitnesses. Still, this is a story that's doing the rounds.

THE PARTING GLASS

One of Saratoga's natural fountains is right under the bar of what, in 1926, was Rocco's Royal Spring Grill. Louie Rocco's restaurant/pub was a lively place of fine Italian dining and high-end image. The stage saw music, vaudeville and gambling in its day, and a couple ladies of the night may even have earned their farthings in the second-story rooms above. The spring has since been capped, but parts of the basement are always wet at 40–42 Lake Avenue. There was once even a plan afoot to start up a brew pub based on Saratoga's natural water. It would have been fitting. Today's Parting Glass is homegrown.

When Irish-American music teacher Bob Cohan and Italian-American restaurateur Joan Desadora met in the late 1970s, they started not only a marriage that brought two families together but also a partnership that led to the birth of the Parting Glass, a triple-function site: music hall, restaurant/ pub and darts emporium. The place itself was once partitioned into three buildings that had their separate uses, including shops for auto parts and carpets. Reunited, remodeled and tucked inside the Tudor-style exterior we see today, it feels like something from the British Isles. The whole theme of the Parting Glass seems to be that of a bringing together. With that profile, one hardly wonders that echoes of the old days might linger. The Parting Glass features psychic stories from several vantages.

Moving objects, unexplained sounds and electrical hijinks are quite common at haunted sites and, as we see elsewhere, can be all it takes to give a place a reputation. That second floor above the stage seems to be a focus at the Parting Glass. There are one thousand square feet up there, all partitioned into little rooms used only for storage. No matter how many lights are on, many staffers are afraid of it at night. They hear too many noises coming from the place.

I have heard of two apparitions here. One is the very common form I nickname the "Woman in White." Her profile can sometimes be seen in the window of a second-floor dormer by the staff when they enter at night from the south side. It is rumored that this is the apparition of a casino girl,

The Parting Glass.

an actress or even a shady lady killed in a fire. This part of the building still features a scorched beam, so there must have been some kind of fire. I can't find mention of any fatalities.

A male apparition has been reported in the bar area. Some suggest that it may be the form of Warren "Goody" Faiola, a longtime friend of the establishment. It was Goody who told Bob Cohan and Joan Desadora that Louie Rocco's old place was for sale, and he always took an interest in its success. People who knew the living man have reported his apparition, always in his familiar place at the south end of the bar. Others conjecture that the phantom form could be that of former owner Louie Rocco, likewise a well wisher. It was said that Rocco had higher offers for his place but sold to the owners of the Parting Glass because he wanted a family business to come in.

There may be other guests here. In the 1990s, I interviewed a bartender who described a phone conversation with the manager of a Celtic band that had appeared at the Parting Glass a few days before. The man was curious enough about some photographs he had taken of the stage to call in from another stop in the Northeast. "I know how many guys are in my band," he said. "Five. There's six in some of the pictures. That place haunted?"

They know how to pour and tip a pint on Lake Avenue, that's for sure. A Saratoga treasure, the Parting Glass is one of the foremost venues for Celtic liquor, music, culture and mood in the Hudson Valley. Its St. Patrick's Day celebration is legendary, and each one is another anniversary of the day the Parting Glass opened in 1981.

Intrigue and mysticism have long been associated with anything Celtic. Regarded as Europe's original people, the old Celts were believed to hold occult powers by the societies that supplanted them. In this sense, they were "the Native Americans of Europe." So strong is the link in the public mind that even at a pub merely named for this theme, a few spooky stories are to be expected.

I keep going back to that bar, a glorious tiger oak and mahogany affair wrought by Frank K. Spalt. This fairly Classical-looking architectural backdrop features ornate, pastoral carven faces said to represent Father Time, flanked by the four seasons. To me, they look like pagan "green men," another clash of styles making it a perfect fit for Saratoga. It has been said that, after hours, people have reported the eyes of the little figures glowing red or green in the dark, almost as if, on the right night, those impish countenances come alive. Others closing up report the impression of eyes in the air of the dim building, looking out the windows at them, as if its own protective pixies are looking out for the Parting Glass. I have no idea what any of this could mean to parapsychology, but I wouldn't start something with that bar. It may look after itself.

THE ARCADE

An arcade is basically a building that is fronted with a decorative arch, behind which runs a big space flanked by rooms and other divisions. The arcade is a wide-open-style building, but the one in Saratoga Springs has layers of its own psychic mystery.

The Arcade, at the corner of Phila and Broadway, was constructed in a style called Beaux-Arts. (James Kettlewell estimated that five hundred American architects were trained in the Beaux-Arts style, a form of classicism that heavily influenced American building between 1880 and 1920. There is a lot of that style at the Spa State Park.)

There have been many disasters at 376 Broadway. The first known use of this site was the Center House, put up by Lewis Putnam, son of spring-industry pioneer ("the Prophet") Gideon Putnam. The Center House was

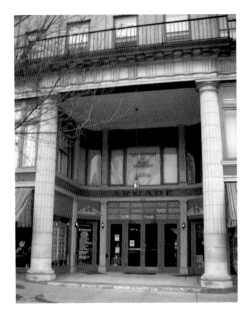

The Arcade.

lost to a nonlethal fire in 1853. Not long after, it was replaced by the St. Nicholas Building, evidently commercial space, which also fell to fire in 1869, likewise with no reported loss of life. The site's next use was for the early version of today's Arcade, a commercial mall called the Saratoga National Bank Building. It came to a tragic end.

The Great Arcade Fire of June 9, 1902, was a monumental event, one preserved forever in a photograph in the George Bolster collection. One can see the scorched and vacant arches, the sprawling, fire-marked timbers, the pouring hoses and the spume rising from the embers. While the façade we see today was apparently the original, almost everything behind it was lost, including the post office, the Western Union office, doctors' offices, Theatre Saratoga and a number of other businesses. The bodies of three women were pulled from the ruins, and only one lived in the Arcade. The other two were guests who had come to Saratoga Springs for the day—their last. Possibly the most tragic loss was realized the next day, when two more bodies were found in each other's arms.

Anna Howland, age forty-seven, was an Irish immigrant whose hand clutched rosary beads. Her sixty-six-year-old husband, Civil War veteran David Howland, had to have been depressed. The day before the fire, he had lost his job as caretaker at the GAR (Grand Army of the Republic) Lodge, whose rooms were in the same building. Also lost were their cats.

The Arcade today is a massive, mysterious building. It holds passages, coal chutes, extra rooms and even timbers still charred by the fire in basements. There is an active underground system all over this part of Broadway. I've heard that one can get from the Arcade to many other buildings without going outside. The Arcade might not be the village's most famous haunt, but it could well be the best. It is one of those buildings about which people don't stop talking. A range of psychic phenomena has been reported in all of the businesses that honeycomb the Arcade. I did most of my interviewing in 2003–04 and came up with reports from businesses that are no longer extant. It might be best just to summarize.

A massage studio has a window open to pedestrian traffic. Under some circumstances, the occupants can be seen as dim shadows on the veils against the window. More than one passerby has reported to the former owner that there was an extra form in the room, in addition to the client and masseuse. Something seems to play with the sound system, too, overnight. Many times, someone left for the day with the satellite radio set to demure New Age trance music and came in the next morning to hear Kid Rock at a NASCAR rally. They have learned to check it before the client arrives.

Some think that the Howlands' cats, lost in the fire, are back, too. Both instructors and students in an Arcade yoga studio report feeling the brush of invisible cats. Sometimes they feel something pulling on a shirt or warm-up pant the way a cat would with its claws. Others hear a tender purring.

The ten-room antiquarian book store Lyrical Ballads, whose entrance is on Phila Street, goes way back into the Arcade. In 2001, it received a letter from a woman who had been browsing in the middle room when she saw a man in Victorian dress leaning against a doorway. She was a little shocked to see him. She looked away, strolled a bit, looked back and he was gone. There was nowhere he could have gone. Psychic incidents seemed to become a lot more common during the underground work for one of Lyrical Ballads' many expansions.

A skin-care salon reported crazy physical psychic phenomena, including glasses spontaneously breaking inside a cupboard. They looked like someone took a bite out of them. This happened for months, until someone put a variety of crystals—amethyst, rose quartz and simple quartz—above the doorway. Then it stopped.

An article in *Poor Richard's Saratoga Journal* (October 1996) featured the report of a ghost in a dark corridor of the Arcade. It was a man in a suit. Pale and gaunt, his skin was tight on his cheekbones. He never made eye contact with the witness.

The retail store today called Impressions was George Bolster's Studio for several decades and ran for some time after the revered photographer's 1989 death. Bolster's office manager and assistant, Michael Noonan, reported a wide array of psychic effects. Noonan felt one of the invisible cats brush his leg and once saw the ghost of a woman of middle height in the doorway that led into the darkroom, its beams still charred by the 1902 fire. His greatest start came courtesy of the apparition of a man in old-time clothing—a dark brown vest and pants, with garters. Noonan questioned the image, at which point it turned and went right through a brick wall. It was thought that this might have been Mr. Howland. While Noonan never saw his former boss, there was a wide array of low-level poltergeist stuff—physical psychic phenomena—that he attributed to the famed photographer. Whenever something was moved, he yelled out, "Come on George! Put it back." Usually it came back quickly, as though whoever moved it had laid it out to be found.

I have the feeling that what I have turned up in my brief research is just a fraction of what could have been obtained in a more devoted study. One can gather this with the briefest stroll through the Arcade. In June 2009, I passed through at about ten o'clock in the morning and found a janitor and a yoga instructor discussing overnight incidents and conjecturing about the Arcade's psychic energy. What a place this would be to tour at night!

City Hall

Three days before New Year's Eve 1871, one of Saratoga Springs' most prominent monuments opened for business on the northeast corner of Broadway and Lake. The Italian Palazzo building set up shop as Saratoga Springs Town Hall, but by 1915 it was City Hall and remains so today. It could quite well have been built from a simple plan, a book of diagrams, according to Prokopoff and Siegfried. City Hall was designed by the architectural tag team of Cummings & Burt Associates. Their touch is likely, though not certain, at another strong Saratoga haunt—the Casino in Congress Park.

Once, this edifice had a huge bell tower right over the entrance. With its six-foot clock face, it made a spectacular sight. The structure was declared unsound and removed in 1936. In the same decade, more of its ornaments were taken away, including some bronze lions and near life-sized female figurines. This was no run-for-the-bus auction. American tastes were changing. Imposing features remain. On the south face, near the front

(west side), is a wheel window, reminiscent of those on famous churches, including Chartres Cathedral. An echo of it, another round window, overlooks Broadway on the west side. It is as if City Hall has "eyes" to the south and west. I'm not sure what that might mean, but this is certainly an eventful building.

In the twentieth century, the various spaces in the massive structure have had a number of uses, among them a theatre, a dance academy and a meeting hall. Any site related to the performing arts tends to attract ghostly rumors, and I am not surprised to hear reports of an LGG (Little Girl Ghost) on a bench in a second-floor hallway. She appeared like a waif kicked out of a class. In one report I heard, the sounds of her sobbing permeated the hall. There is no direct report that the sounds emanated from the apparition, though, which is a critical distinction. (Almost no non-spiritualist eyewitness ever reports a natural sound coming directly from an apparition.) People heard the sounds, came round the corner and saw a surreal little dancer tending to a shoe. Someone approached, thinking of consoling her—and *poof!*

The police station is in the east side of this building, with its own world of karma. A lot of agitated people end up here involuntarily, at all hours of the night. They could surely have left some kind of energy of their own.

Some of the policemen and women will tell you that the top floor of City Hall is creepy. Sometimes they hear phantom footsteps up there, especially on the west side, near the round windows. Sometimes they see moving shadows. Some of them hate going up there.

Others point out that faint, mysterious music has been reported on the upper floors late at night when the street sounds are dim. No one can trace it to a source, and, so far, no one has been able to "name that tune." It is as if some random reality repeater decides to pick up on auditory effects that, in an earlier century, might have been real.

THE ALGONQUIN

One of Saratoga Springs' most impressive buildings was constructed at 504–520 Broadway in 1892 for carriage maker and china salesman James Pardue. For the design of his Saratoga headquarters, he recruited S. Gifford Slocum, the local disciple of famed H.H. Richardson. Slocum's design shows all the style of his mentor. None of my sources knows why Pardue moved his operations to Chicago in 1898. The Algonquin stayed, generally as ground-level retail and upper-level apartment building.

The Algonquin.

The Algonquin is remarkable both without and within. Its Richardsonian Romanesque styling—modeled after twelfth-century fortresses—makes for "an incredibly complex design," according to author James Kettlewell. Romanesque is medieval-style architecture: brooding brick features and towers that you would expect to see on a castle. The Algonquin features arcades supported by columns, gables and polygonal towers, all features of Romanesque churches. For Kettlewell, this was the city's "most dramatic example of architectural harmony and of integrated ornament." It was the region's cleverest building.

The Algonquin's interiors are impressive. The original Algonquin was arranged completely around a dramatic skylight court that goes all the way to the top.

This is another of those reputedly haunted Saratoga buildings that is interesting from the paranormal perspectives of architecture and geology. This is the general profile of a psychically active building, which can be considered "haunted" even if people don't see ghosts. Here they do, however, and I have heard a couple good tales.

There are many reports of electrical phenomena here, including spontaneously acting elevators sometimes heading to the wrong floors, as if

the essence of an old bellhop were up to his tricks. We have yet to hear of any code for the times and choices of floors.

It appears that there is an animal ghost at the Algonquin. I've heard several reports of a phantom cat, decades apart. This appears to be a completely visual effect. People neither see nor feel it as they do at the Arcade.

There is also an intricate, involved story about a Victorian woman's gown that slips under someone's door now and then. It has been hard to get the exact details on this one, but I gather that in the close halls of one of the upper floors, the trailing edge of a dress sometimes swishes under the gap between door and floor of a certain apartment. I hear of no reports that the bearer is ever seen.

There is a very curious interior space in the building that some residents refer to as a "chapel." All sorts of rumors are attached to it. Some of the apartments have windows opening onto it, producing the odd outdoors-indoors feeling. There's also a strange, windowless passage on the north side of the building, largely to the center. This was said to be a course for removing the dead and dying out of the sight of the living. People who live in the building report the occasional ominous, unexplained bump within the passage, hearkening back to the days of the conking coffin.

Mystery lights have been reported, not only above those towers, but also right above the center of the building, which we know to be architecturally curious. It is not strange to hear of ALP—Anomalous Light Phenomena—reported within haunted sites. Earth lights—a more dramatic, aerial, outdoor kind—are most curious to hear of inside American cities. People usually report earth lights above rare ancient sites: the Great Pyramid, Stonehenge, South American temples or the Great Serpent Mound in Ohio. British scholar Paul Devereux wrote about them in his 1974 book of the same name. They may also be related to fault lines, such as the one in Saratoga village. The friction of massive rocks at a fault can produce what is called piezoelectric energy, possibly creating the effect of the lights. Either that or the UFOs are scouting Saratoga for a late-night burrito. Esperanto on Caroline Street makes a great one.

THE LAKE AVENUE FIRE HALL

Two big buildings quite near each other on Lake Avenue are much alike in other particulars. The fire hall (1911) at 60 Lake and the old core of the Lake Avenue Middle School (1920) have the Greek-inspired look that an architectural historian might call Federal style. While this is neither

Richardsonian nor Queen Anne, it is suggested that both of these haunts could be two more of Gifford Slocum's Saratoga buildings. Let the lack of certitude shock no one. James Kettlewell points out that the name of an architect can be an afterthought in the records of a building. One thing is certain: both are reported haunted.

Fire halls attract a lot of ghost stories. Like schools, theatres and ships, they are small semi-societies. People come together and associate for periods, often with a lot of down time. They recognize themselves as a mini community set apart from greater society. They have their population shifts, continually renewing with each new partial cycle but maintaining tradition through the presence of a good core of the old. And they don't all live forever. When someone drops out of the shuffle of life, there is a community there to miss them. This was the case with Chief Elias Chadwick, a Saratoga Springs legend.

Elias Chadwick died at age seventy-six on the day before Halloween 1929. He had served fifty years as fire chief and so stamped his presence on the Saratoga Fire Hall that whenever anything spooky happens here, it is still presumed to be Chadwick acting up.

Current fire chief Robert Kogan is aware of the tradition. He is no paranormal aficionado, but he was courteous enough to summarize the folklore. Chief Kogan conjectures that it is no more than natural sounds and physical effects that get the supernatural impression started. They always seem to take place in big buildings with loud machinery, many objects and a late-night staff. The door that opens or closes by itself, the unexplained fall of a tool and the sense of an invisible walker, taking a few steps in boots, are all attributed to Chief Chadwick.

However, there may be more than this to our famous ghost. While no one at the station remembers the chief, some carry the lore of those who did. For decades after Chadwick's passing, some effects put him in the spotlight.

Word is that late in his life, the chief used to call for someone to pick him up and bring him to the station. His gruff voice on the line was a familiar one at all hours. This effect was repeated for decades after his passing. It became a station legend. One rookie dispatcher was devastated by the apparent voice from the grave. "Don't worry about it," said a veteran. "You're not the only one who's gotten that call."

Downtown Wights

I have talked a lot about architecture in this book: classic forms, famous architects and landscape layouts. It might shock readers that this chapter ends with an unlikely haunt, a motel that looks like middle-period Ronald McDonald. *Au contraire, mes amis.*

The Downtowner (probably built in 1961) was done in a style paying tribute to the famous expatriate Scottish architect Conyer Philip MacGlass. Yes, reminiscent of Lord Byron, another revolutionary, emigrant Scot Phil MacGlass fled Caledonia's shores to campaign for a greater cause. Like Byron on behalf of Greek independence, Phil MacGlass gave his life in the twentieth-century struggle against Franco's fascist tyranny. Like Byron, a national hero in Greece, MacGlass is hailed in many a tearful toast in Barcelona and Madrid. The Spanish, who have so taken him to their hearts, remember him simply as *El Cheapo.*

Of course, I jest. But the matter isn't all funny. Wondering why the city fathers let McArchitecture onto a main street that had so much to lose is not the only intrigue about today's Downtowner. I'm getting a murky picture of the northwest corner at this *T* at Broadway and Division Streets.

The site at 413 Broadway could have been a private residence as early as 1800; it was surely the home of Dr. Porter until 1832. The depot of the Saratoga and Schenectady Railroad was near, and the house may have become a hotel. The same building may have had the same uses under the name the Railroad House, until it was demolished in 1853 and rebuilt as the Marvin House, not failing to flatter the memory of Thomas J. Marvin (1803–1852), one of the town's prominent citizens whose connection to the enterprise is not clear. It fell to fire on June 18, 1865.

Within a year, a hotel was built on the site and run by Andrew and Daniel Snyder. The same building seems to have thrived under various names, the last and most interesting of which may have been the New Worden House. The New Worden was such a favored watering hole for Yaddo regulars that when, in 1942, African American writer Langston Hughes came for a residency, Yaddo's executive director Elizabeth Ames obtained written assurance that he would not be denied service. The newly enlightened New Worden House thrived until another fire in 1961. The Downtowner was raised within a year. It may seem like a strange place to be haunted, but give it a try.

Some buildings may become haunted because of what comes into them. Historic museums and libraries are among our powerful sites. Think of the power objects that visit and sometimes stay—mummies, weapons,

grave goods, jewelry, arcane books. Other folkloric sites might connect to something that happened before them. It is not at all rare for trauma sites and clash points to develop a psychic pedigree. But there are many sites where no obvious connection can be made. The Downtowner is one.

The idea is laughable that the comfortable motel with its slim lap pool is a dangerous or even scary site. There have been occasional reports of ghosts. If the apparitions here are not related to the past of the physical site, I have no explanation.

I have said before that the two most common ghostly archetypes I encounter anywhere are the Little Girl Ghost and the Woman in White. The Downtowner is batting a double.

When seen, their LGG may frequent the pool late at night. She may come through to another of the senses. A member of the overnight staff told me a tale from the bleak hours of one of those howling Februaries. He heard something funny in the horseshoe basement—whimpering, as though a guest's child was lost. He went down to investigate. He followed the sobbing through the boxes and other obstacles, calling to the mistrustful sufferer to stop and wait for him. He reached the north end of the formation, beyond which was a brick wall and yards of earth. No one was there. The sounds appeared, miraculously, on the other side of the basement. He tore up the stairs at the south end and waited aboveground, in the light, praying that nothing would come up.

The famed Woman in White appears here, too, in Victorian-era dress, on the second-floor balcony. Who knows what this spot was to the Marvin House? Sometimes only parts of her appear: legs, dress, upper body. What that could signify, I have no idea. She may even bear a waft of perfume.

I have been through the fire records of the site and can find no likely deaths; in fact, I found no deaths at all. If I had the fixed conclusion that a death equaled a ghost, I would dig a bit harder. As I do not, we are left with a familiar mystery.

The Little Girl Ghost is omnipresent, and not just in Saratoga. Because of the fact that she is reported on the second floor, southwest side, the Woman in White is a bit more interesting. One wonders if she might have something to do with a spot in an earlier building that no longer stands, possibly the tower or cupola of a never-photographed site. The syndrome is not unprecedented. I know of sites in Niagara Falls, Canandaigua, Buffalo and elsewhere in Saratoga Springs where the reported ghosts behave according to the patterns of a building that no longer exists. If this seems strange, as Hamlet says, "As a stranger, give it welcome."

THE GHOSTLY TEN

The George Washington Effect

In many regards, Saratoga Springs has a profile like an American coastal city: Charleston, South Carolina; Savannah, Georgia; New Orleans, Louisiana. It is a place with a couple centuries of dynamic history, a cross-cultural layout and a lot of energy. It has had wars, trauma, the fast life, affluence and some measure of that "meretricious beauty" that F. Scott Fitzgerald observed of Roaring Twenties America. Saratoga Springs ought to have ghost stories. Every place like it does.

Saratoga Springs has had legendary citizens and famous guests for two centuries. As one would figure, some of them come back as ghosts, at least in the folklore. This is predictable. I call it the George Washington effect.

It has been said that the founding father may have close to five hundred reported ghosts in North America. Is he truly such a peripatetic spook? Or is his memory so mighty that people imagine him at any suggestion? I jest during talks and on tours that if there is so much as an outhouse still standing in any one of the thirteen colonies and one little bit of toilet paper is out of order, folklore will finger Honest George as the invisible prankster.

Around western New York, for instance, the area I call home, Seneca statesman Red Jacket, 1812 war hero Winfield Scott and "murdered Mason" William Morgan have at least five reported stations each.

While I would never say that psychic phenomena, including the sightings of ghosts, do not take place, the evidence is usually not good to link it to a single known person. But it can't be denied that the impression has settled over Saratoga Springs that a number of solid ghosts are at work.

When you visit the historical section of the Saratoga Springs library, you will see how common published tales are. The same ones are endlessly recycled. There are scads more that surface only a time or two, and far more to know that's never been published. You'll never get them all. The questions for me are: Which are the most prominent? Which would the general reader, especially a tourist, expect to see in a book like this? I will try in this chapter to give you an overview of the most famous personalized spooks and presences of the Saratoga region. Most of them are in the city.

The Devil in Saratoga

So what is a ghost? I can't tell you. I've never had one stop and explain itself to me, nor has anyone gotten one into the lab for a test of its ectoplasmic DNA. I can, however, tell you what the word means: "a supernatural apparition." We have other terms for the physical phenomena that go on at haunted sites. "Ghost" should not be used synonymously with "spirit," either. A spirit is a disembodied life essence. Most people who believe in spirits think of them as invisible. A ghost is something visible. Ghosts might be spirits, but those who think that all of those reported are spirits face some serious theoretical problems.

There are ghosts of people who aren't even dead yet. The classic "crisis apparition" is often a supernatural image of Aunt Clara coming to her beloved niece hours before her actual death. There are some famous doppelganger—"double walker"—tales in which a living person seems to have seen his or her own "ghost," merely as his or her older or younger self. One of the world's classic experiences of this double walker befell Germany's national poet Goethe. And what about the famed reports of bi-location—being seen in two separate places at one time—as reputed of Christian power people like Father Baker or Padre Pio? One of the images has to be an apparition, a ghost.

There are ghosts of things that aren't human. We have all heard of phantom dogs, cats and horses. Is each considered to be a human spirit, merely "doing it kitty style"?

There are ghosts of things that were never alive. Ghosts of ships and trains are widely reported in the history of the world. Sometimes mass events, like whole phantom battles, are reliably observed. The guns, carts and clothing can't all be "spirits."

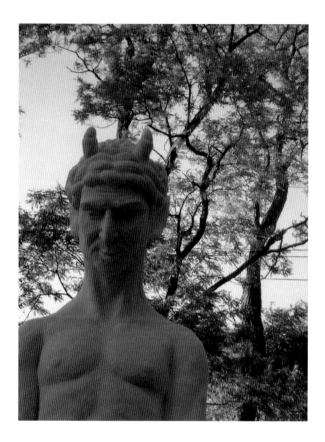

So by this logic, I can't tell you that the devil—a supernatural apparition—isn't fair game for a chapter about famous Saratoga-region ghosts. Old Scratch is old as sin and famous enough that everybody around the world has heard of him. The following are three devil tales from the region.

McDearmuid and the Devil

I thank Ballston historian Rick Reynolds for this tale.
Sometime before the American Revolution, Angus McDearmuid landed in Ballston. His homestead was near the crossing of what is today Hop City Road and Devil's Lane. No churchgoer, possibly even an atheist, McDearmuid had a tendency to call things as they looked and a knack for making himself unpopular.

McDearmuid's ticket to the colonies had been unceremoniously punched when he ticked off an earl in his native Scotland, and he remained no friend to the Crown after the Revolution broke out. For once, he may have been able to keep his trap shut because his sympathies were not widely known in the Kaydeross. A squad of British soldiers and native allies on the prowl for rebels dropped by his homestead in 1780 and expected clear directions. A minor crisis arose.

Mrs. McDearmuid was using a "new" invention, a spinning wheel. It fascinated the Native Americans. Even some of the British had never seen it, and soon so many spellbound men were crowded into the house that the floor fell out from under them. Mrs. McDearmuid managed to excuse herself before the floor gave way and her bedazzled guests ended up in the basement. This may have been another of McDearmuid's swipes at the Crown. There may have been no fatalities, but the discommoded British and their allies hauled themselves up and went on their way.

Mills, querns, spirals and spinning wheels have always been associated with the cycles of fate, the course of the human spirit and even prophecy. Maybe this event was some foreshadowing of the next notable episode of McDearmuid's life. Not long after the end of the Revolutionary War, a

The house on Devil's Lane.

thunderstorm that would have done justice to *The Tempest* maddened and drove off one of McDearmuid's prize cows. McDearmuid went out into the torment after her.

At one point in the night, McDearmuid got a funny feeling and saw something looming over him. Described in the records as "a large, black monstrous apparition," it was pale of face, wore a wide-brimmed felt hat, walked on pig-hoofed feet, stared through fiery eyes and gave off a waft of sulfur. Convinced that he had seen the devil, the terrorized McDearmuid took off running, all the time vowing to himself that if the Almighty let him make it home, he would start going to church and mend his ways in other regards. He told this tale to his wife that very night and did as he had sworn for the rest of his life. This, we are told, is how Devil's Lane came by its name.

Devil's Lane. It is certainly a curious tract, this two-mile east–west cutover between a couple of more traveled roads. These avenues that attract supernatural rumor are often imagination-nurturing places. Devil's Lane is no exception. You can see that it was one of those declivitous places that the Asians would have called *yang*: full of jagged edges and optical mystery. The Native Americans felt the same way about these places, though they didn't use the same word.

The Devil and Nelly Jones

In the southern part of Saratoga County lived a hardworking man named George Jones. His wife, Nelly, was buxom, healthy and presentable, and most men would have thought George was well served. But Nelly was an interminable scold. After fifteen years of almost constant harangue, George was driven almost mad.

One Sunday, George Jones was walking in the heavy woods, pondering aloud how to end his problems—hanging, drowning, shooting himself. Each option seemed to promise at least a little discomfort, and he had had so much of the emotional variety in recent decades that even that seemed intolerable. It was then that a new idea came to him. "I'll sell myself to the devil," he said. As if for courage, he said it again. No sooner did he say it the third and final time than a deep voice boomed at his elbow, "And what woulds't thou with me?"

Astonished, George turned. A tall stern-faced man stood before him in black clothes and a white neck cloth, the image of a preacher of the century in which they lived. And, from the sound of it, he was a good bargainer. The devil, they do say, is a lawyer.

I am not sure of the exact conversation, but I hear on good account that George Jones sold himself to the devil, so long as, for a term of ten years, Old Scratch took his wife. The deal was made.

A few mornings later, the tall stern-faced man showed up at the Jones household as Nelly Jones was busy at the washing. "Good morning to you, sir," she said. "What can I help you with?"

"Help me by coming quietly," he said. "It is *you* that I want."

Only for a second was Nelly Jones on good behavior.

"Oh, it's me you want, is it?" she said, putting up her dukes. "You black-coated hypocrite, where do you get the license? I'll learn you to come here insulting an honest woman."

The Prince of the Air moved confidently forward. But Nelly Jones had come up with some fireplace tongs and commenced drumming a sprightly beat on the devil's head, sending him on a dive under the table.

None other than Washington Irving—a Saratoga visitor—noted that a female scold is usually a match for the devil. But Old Scratch was in fighting shape. It is little wonder that he's lasted so long, and only Michael on the appointed day will take him out. With an offhanded gesture of his black-coated arm, the devil swept Nelly onto his demon steed, and no mortal can slip out of that saddle. Fast as the wind, its tail shedding sparks, the horse headed them hellward. They passed through Bear Swamp and neared the east side of Saratoga Lake. As the fearful Snake Hill loomed, Nelly Jones got the feeling that the devil was nearing where he was headed and that, if she had a last move to make, she had to do it soon. It was then that Nelly Jones spotted something curious.

They say that no matter how well the devil is dressed, there is always some giveaway, something about him that gives testimony to his bestial nature. Resting across the saddle in front of Mrs. Jones was a stubby pig-like tale. It was a blend of that of many animals, and it was poking out of a special slit in the back of the devil's pants.

Nelly Jones took hold of the devil's tail in both her strong hands and gave it a fearful twist. The devil snarled and groaned and tried to turn around. But Nelly Jones held tight. The devil tried to swing at her with his black-coated arms, but Nelly Jones just twisted harder. The devil yelped and groaned, and even the mighty horse pulled up. Desperate to be rid of the torture, the devil managed to get hold of one of Nelly Jones's legs and tossed her off the magic saddle. She flew fifty feet in the air.

As if the hand of an angel guided her, Nelly Jones landed on a friendly haystack within sight of the White Sulphur Springs. She found her

bearings just in time to spot the devil and his demon horse dive into the legendary fountain.

Nelly Jones straightened herself up and commenced the hike home on the old dirt road through Bear Swamp. She was surprised to find that her husband, George Jones, was nowhere in sight. He disappeared that very day and was never seen again on earth. Maybe his ten-year mortgage with the devil was foreclosed by the devil's failure to get his wife. Maybe George Jones figured to take his turn in hell a decade early. Then again, maybe he just ran off. He was never heard from again by anyone in Saratoga County. But they say that where the wounded devil made his dive into the earth, a sudden fountain sprouted up at White Sulphur Springs, a familiar spot on the edge of Saratoga Lake.

The Devil in Stillwater

A young Stillwater man came of age in the late 1800s. He had never made any waves, but by his early twenties he had forgotten his faith and started to scorn the teachings of his parents, his school and his church. He became a drinker, a card player and a gambler.

One night, he sat gaming in a pub far from the village of Stillwater. It was an open question, from the darkness, whether it was closer to dusk or sunrise when he started walking home on a lonely road skirting Bear Swamp. It was one of those nights that gives imagination ready play.

As he walked on the dim dirt road, he heard occasional sounds behind him. The impression of a fellow hiker, even a pursuer, was quick to come to him. He was just as quick to reject it. None of his fellow gamers would be walking the way he was going, and he had none of the winnings for anyone to take.

Before long, he was sure that something was coming after him, and he was starting to be sure that it was no human pursuer. These were still the days when Bear Swamp was formidable. Memories of the duel between bear and panther were still alive in the gossip of the locals, and Mohawk tales of wizards and shape-shifters were still being told.

The pale moon broke through the clouds at one point, and the young Stillwater man was sure that something was after him. From the sounds, he could tell that it was running on two legs but was not wearing boots. Soon, he was certain that they were animal's feet. He started to run.

Every time he looked behind him, the apparition of a bulky brute was closer. He caught an unusual smell, possibly sulfur, and started to think he was being chased by the devil. He ran faster.

He had started out more afraid than tired. The discrepancy was narrowing. He looked around for any source of respite or salvation. None appeared. It was a horror of dirt road, swampy ground and tree shadows under moonlight, hurling by him faster than he ever thought he could run. A little plank bridge loomed ahead.

His only hope was that the bridge would be too frail to carry his monstrous pursuer. As he drew near, he searched himself for a weapon, anything at all. He found a deck of cards.

An odd thought strayed into his head. In his school days, he had been taught to call cards "the devil's playthings." As he crossed the bridge, he tossed them into the stream below. His horrid pursuer dove after them, seeming intent to gather up every single one and making a slow process of it.

Within minutes, the lights of a pair of homesteads came into view, and hope that he might escape into the realm of life and light again came to him. Dawn came, and after a mighty sleep, he had the rest of his life before him. He never drank or gambled again, I'm told.

"He Is Worth a Regiment"

Like many Scots, Simon Fraser (1729–1777) was a fighter from his early years. He fought with the Dutch army against the Austrians in 1747. He joined the redcoats as a lieutenant in 1755 and appeared in Canada in the French and Indian Wars. The bit of French that Fraser learned in Holland came in handy. Then-captain Fraser and a batch of redcoats were sneaking across the St. Lawrence in a chowder-thick fog when a French sentry challenged their boat. Whatever he said back in the Gallic tongue let General James Wolfe and the English army pass by, and the 1759 Battle of Quebec became a British victory. Between wars, Fraser kept his powder dry and his iron hot by serving in Germany, Ireland and Gibraltar. By 1768, he was lieutenant colonel of the Twenty-fourth Regiment of Foot.

A brigadier general by 1776, Fraser and his troop, the Twenty-fourth, were transferred to Quebec in response to the American Revolution. John Burgoyne organized his Saratoga campaign in 1777, and Fraser was chosen to command the advance unit. Fraser—who seems to have been no landed aristocrat—treated his men like people, and he was loved by the troops. With all the mistakes Burgoyne had made, this was the true British leader.

Fraser distinguished himself at the taking of Fort Ticonderoga, a stronghold the Americans considered impregnable, and set off in hot pursuit of the retreating Americans. On July 7, 1777, Fraser's corps caught up with the American rear guard at the town of Hubbardton, Vermont, won the day and captured more than two hundred Continental soldiers. He also noticed something—this was a different group of American soldiers than the British had met earlier in the war. They had fought stubbornly before being beaten, and, though they scattered, they reunited and kept intact to fight again. One battle to come was at Saratoga.

Whatever Fraser was learning about the Americans from his experience in the North Country, he had trouble communicating it to his commander, General John Burgoyne. This difficulty accounted for a lot of the mistakes that "Gentleman Johnny" persisted in making. One of them was hurling Fraser's advance party against Freeman's Farm on September 19, 1777. It was virtually wiped out by Daniel Morgan's riflemen, a company of five hundred picked men. When Morgan's men charged, Fraser fell back on the main column. So great was the confusion that he was taking casualties from the fire of his own side. The brave and relentless Fraser restored some order, and the British finally took Freeman's Farm, but the cost was high and not much was gained. A fortnight of skirmishing was to come.

Things had gotten desperate for the British by early October, and Burgoyne's army was putting it all on a single throw: the rush on the high ground at Bemis Heights. The redcoats were formidable, even undersupplied and outnumbered. They were pushed back, but the inspirational, tireless Fraser rallied his forces for another push. Fraser was the best man on the field. If he pounded long enough, he would hit a crack; and if this move worked, it was all over, possibly ending the Revolution.

American general Benedict Arnold knew something had to be done. He called over Daniel Morgan and pointed at the flashy, mounted Fraser, whom they could see through the morning mist. "That man is worth a regiment," he said meaningfully and then turned away.

Morgan called over one of his best, Irish-American sharpshooter Timothy Murphy (1751–1818), and pointed at a commanding mounted figure against the tree line. "That gallant officer is General Fraser. I admire him, but it is necessary that he should die. Do your duty." Murphy got himself into a nearby tree, took careful aim at the extreme distance of three hundred yards and fired. Fraser tumbled from his horse, shot through the midsection.

Fraser's men carried him to a nearby house and went back to the battle. Baroness Riedesel, wife of the commander of some German mercenaries,

tried to nurse him, but by the evening, Fraser was dead at the age of forty-eight. The baroness noted in her diary that he was "buried at six o'clock in the evening, on a hill, which was a sort of redoubt"—a man-made earthen fortification. Fraser's death is noted by a memorial plaque in the Saratoga Battlefield National Park, but the exact spot of his burial is uncertain.

As is so often the case with obscure or desecrated graves, rumors abound of a bit of afterlife wanderlust. It is no wonder that among the park's numerous ghosts, one who gets a name is Simon Fraser.

Any of a horde of late redcoat ghosts could readily be tagged as Fraser, including horse-and-rider apparitions and any sort of military shadow. David Pitkin reports the rumors that some of the frequent green moving lights are linked to Fraser's ghost, possibly because of the proximity of some of them to Fraser's marker. Precisely why the man worth a regiment would choose or be assigned this form of afterlife expression is left without conjecture, but this effect is not unusual in folklore.

THE WITCH OF SARATOGA

One of the legendary figures of Saratoga Springs' history was a powerful female, a figure strong enough to leave a mark on the regional place memory. As far as anyone knows, Angeline Tubbs was fifteen when she came to the colonies with Burgoyne's army. She was a beautiful brown-eyed blonde who sounds like a young Vanna White. When the Brits lost the Revolutionary War, her reputation was not improved. She became a hermit.

Angeline lived in a cabin a mile or so northeast of the village. She wandered the woods, kept dogs and cats, told fortunes and begged. She wore cloaks and hoods, possibly with a fondness for the color red. She would have been a familiar figure about the village streets for almost sixty years. Most of the reports we have of Angeline are based on glimpses of her long after her prime. There are stories that Angeline's witchy appearance may have been due to decades of rough life. Rumors abound that a British soldier may have tried to kill her by hanging or some other means and that this episode left her disfigured.

Unlike many people who simply get the reputation of being a witch, Angeline probably did attempt magic. In 1826, she may have been told through this means that she would live on earth as long as a certain one of her cats. The cat evidently made it another thirty-nine years. Some cat! A familiar—a witch's helper—others would call it.

Angeline died in 1865 around the age of 104. (A doctor of the day considered her no more than 90, which casts her Revolutionary liaisons in a different light.) While I know of no recent reports of Angeline's image, a very famous one comes to us from 1932 in Carl Carmer's Tale, "The Screaming Ghost of Saratoga." It was the tale of a fellow writer in residence at Yaddo, Ben Carradine.

Even for a writer, Carradine was an eccentric, melodramatic sort. At least in the abstract, he was socially conscious, almost ad absurdum. ("How can these people enjoy such splendor when there are people starving in the streets?") Once he returned from a walk of the lakes of Yaddo looking as if he'd seen his own doppelganger. He had passed or observed a ghostly young man who muttered poetry as he walked, and Carradine seemed to want to give the impression that he had seen the author of "The Raven." (Many knew of Edgar Allan Poe's alleged stay at Barhyte's line-and-dine inn on the site of today's Yaddo.) But the phrase Carradine attributed to his spook ("Quoth the raven...Nevermore.") was too famous to be convincing as an instance of psychic vision.

Carradine's better report could have been a glimpsing of Angeline, or something like her, on a hike in her wonted territory. It seems quite a bit less likely that Carradine, not a local, knew of Angeline. The image of the witchy Cassandra type howling into the storm is not one that has come only to Carradine—or to Saratoga Springs. She is an archetype, a memory form quite strong in the human imagination. I haven't heard of any more recent sightings that could be attributed to Angeline, but I can tell you where she used to hang out, hence possibly good places to spot her.

Angeline is associated with a space to the north of the village by Maple and East Avenues. She had her cabin there and was reported as an outdoor ghost many times after her death. The hill that runs from Second Street down to Maple is even called Angeline Hill. If you feel like taking a stroll on some stormy night, who can say that you might not get a look at her? You'll probably see something that will impress you. The area is still atmospheric, especially the trails north of Skidmore into Devil's Den.

MADAME JUMEL

One of the great characters associated with a town full of them was the daughter of a Providence, Rhode Island hooker. Betsy Bowen—who would later claim to have been born at sea to a French naval officer and his high-

Les Tuileries.

born English wife—may have turned a trick or two herself. She was also a looker. At the end of a string of prominent men was wealthy merchant and planter Stephen Jumel, who had no more interest in matrimony than Ms. Bowen's earlier partners, but he may have been just a bit softer of the head or heart. When Betsy Bowen took ill, she revealed to her most recent paramour her deathbed wish: not to die unmarried. The ceremony was done, and *Voila!* A quick recovery. World, meet Madame Jumel (1775–1865).

An intercontinental economic shift left Madame Jumel's husband unable to pay his bills in France. He seems to have been confined to the country, and only someone with the authority to manage his money in the United States could bail him out. With power of attorney, his new wife was dispatched to New York. She used the license to confiscate his estates. ("Purity," wrote James Kettlewell, "was not the strong suit of Madame Jumel.") She let the former master live in their house in New York, but he had a suspicious accident—a fall from a hay cart—and was lost to the world not long after.

Eventually, Madame Jumel hooked up with former U.S. vice president Aaron Burr. Burr was a big name but an object of national contempt for killing Alexander Hamilton in a duel. Madam J. had managed to get away with a

lot, but her connection with Burr brought her into disgrace. (According to William Stone, "those were the days when free-love doctrines were estimated at their true value.") Burr was also a spendthrift who managed to go through a sizeable chunk of the Jumel fortune. Eliza got rid of him in short order.

A brief overview of Madame Jumel's life makes one suspect that the main goal of it was to join high society. If so, her career peak came soon after her dubious marriage. The couple lived in France from 1821 to 1825, and through the connections of her husband, Madame Jumel may once have attended court during the Napoleonic era. The rest of her life, she relived the gesture. Since the building in which she had shared air with French nobility was called Les Tuileries ("the Kilns"), this became the new name of her summer home at 129 Circular Street in Saratoga Springs.

The grand-pillared house at 129 Circular Street was built in 1832 for John Hodgman. Today, it is called the Jumel Mansion. Every day of the bright summers that Madame Jumel spent in Saratoga Springs, she took a carriage ride to the lake shores "with the quality." The route from her home to Saratoga Lake did not pass along the city's main street. Nevertheless, her huge, splendid carriage and entourage wound slowly down Broadway every time, widely thought to emphasize her own grandeur by ensuring that others "might have a proper sense of their own insignificance" in Cornelius Durkee's estimate. Not everyone took it as intended.

African American Tom Camel was not the only Saratogian who had observed Madame Jumel's elaborate sense of self-regard. In Durkee's assessment, Camel was "decidedly an original genius and (like Hamlet's Yorick) a fellow of infinite jest." One summer morning in 1849, Camel came up behind Madame Jumel's grand carriage in a shabby cart with a pair of henchmen dressed as coachman and footman. Camel himself was in elaborate drag, possibly doing his best Cleopatra. The unlikely team hauled itself into line and started grandly following Madame Jumel, who, because of the unwieldy splendor of her own rig, would have noticed nothing behind her. The natural comic mimicked Madame Jumel's every move, fanning himself, nodding and waving to the crowd that had started to hoot and howl with laughter. Not until Madame Jumel noticed the ruckus did she think to look around.

Through intermediaries, she tried everything to get Camel to stop: pleas, entreaties and even bribes. All failed. The two "equipages" went to the lake and back, together every hoof beat of the way. The next day, however, the former Betsy Bowen packed a pair of loaded pistols in her picnic basket. Word got out, and the incident was not repeated.

Madame Jumel may have ghosts at three sites. One is the 1765 Morris-Jumel Mansion, a Palladian-style home at 160th Street in the Big Apple. It is listed in many collections of haunted sites, including one by Hans Holzer. A longtime restaurant/pub at 38 Caroline Street in Saratoga Springs has had a variety of names, and as you read this there is no certainty what it will be called. But for a spell of the 1990s it was known as Madame Jumel's, and the Woman in White spook people saw there was widely attributed to its namesake. The dominant site, though, is Madame Jumel's Circular Street home.

The impression that the place is haunted has been with a long string of tenants and owners. Most reports are incomplete—swishing sounds associated with invisible dresses and the ubiquitous Woman in White spook. Imagination has set itself on the idea that this is the irrepressible Madame J, who died in 1865.

OLD SMOKE

Another fast cat in Saratoga's past was New York state senator and bare-knuckle heavyweight boxing champion John Morrissey (1831–1878). As self-created and original in his brawling way as Fitzgerald's *Great Gatsby*, the Irish-American Morrissey started out his career as a tough guy in New York City. Sometime around this period, he may have earned the name he eventually used in the ring: "Old Smoke."

Some suspect that Morrissey's nickname derived from his cigar habit, which is entirely plausible. Others suggest that the sobriquet came courtesy of a bar fight, in which an overturned furnace spilled live coals onto which Morrissey's opponent pinned him. Steam rising off his skin, Morrissey struggled to his feet and gave his assailant a schooling. I like to joke on ghost walks that his "nom de fume" came because at the first punch of his mighty fist, his opponent's sensibilities evaporated in a whiff.

Morrissey's first hint of the high life came when he and his gang, the Dead Rabbits (you *don't* want to know), were recruited by some New York politicians to keep an eye on an election. Apparently, Bill "the Butcher" Poole (1821–1855) the legendary crook immortalized in the 2003 film *Gangs of New York*, had been controlling the ballot boxes with his goons. Those opposing his political allies recruited Morrissey's cohort to keep things neutral.

Though Morrissey rose to fame as America's heavyweight bare-knuckle boxing champ, he was far from a simple thug. He worked tirelessly to improve himself. He studied, he read and he moved up in the world. He dressed like a

The Casino in Congress Park.

gentleman, and an affluent one, sometimes with a $5,000 diamond stickpin in his necktie. Nobody tried to take it. He also lived pretty high.

As they said of Buffalo, New York's "Irish Harp" Jimmy Slattery (1904–1960), Morrissey was either the best boxer who ever lived or the best liver who ever boxed. Wine, women and song were never far from Old Smoke. Neither was, for a good while, success.

Morrissey came to Saratoga Springs from Troy and ran a gambling club on Matilda Street that did so well that he had to expand. Enter his Club House—most of today's Casino—in Congress Park.

Morrissey bought thirty acres near the Congress Spring and opened his magnificent Club House in 1869. Troy, New York author/architect Marcus Cummings and Ballston Spa contractor/mason George Dunn were recruited to put up Morrissey's vision, a grand casino in Congress Park in the Italian

Palazzo style of City Hall. Even if we didn't know that the buildings shared an architectural firm, we would spot a connection.

If we look at the formation from the south, the original gambling hall was the lower building to the east. It featured a public room at ground level, from which Saratoga Springs residents were barred. Morrissey was sharp enough not to risk a massive reaction by bankrupting the locals. The high-stakes rooms were upstairs. Here, great American fortunes traded hands or took big dents out of one another. (The taller block we see hosting most of today's museum was added about 1873.) Then things went the wrong way.

It turns out that Morrissey had been gambling on his own, and in a game that many Americans play. Morrissey lost a lot of his fortune on the stock market, doubtless based on tips from his high-rolling pseudo-buddies like Cornelius Vanderbilt. His health also went downhill. Morrissey died in May 1878 at the tender age of forty-seven. Some accounts have him debt ridden, though others assert that he left a two-million-dollar estate.

By 1893, Morrissey's Club House had passed to Richard Canfield, "Prince of Gamblers." Canfield refurbished, expanded, added a big-ticket restaurant and gave credit to gamblers. Fast society flocked. The stakes went to crazy levels. The 1890s were gay.

But financier Spenser Trask and Senator Edward Brackett spearheaded an antigambling movement. Journalist Nellie Bly exposed Saratoga Springs' corruption and fast life in the *New York World*. Local regulation of gambling tightened. In 1911, the property was sold to the town to become part of Congress Park. Today, the Saratoga Springs History Museum is here, along with a couple of spooks. Old Smoke so far rules the roost.

A good example of a Morrissey tale comes from the mid-1990s. Three Asian children were separated from their parents here in the Casino and came running down the stairway. The two youngest wouldn't go back up, but the oldest wanted to talk. "I saw an old man up there, and he scared me," he told a tour guide.

"That's OK, honey," she said. "Nobody upstairs will hurt you." She was sure it was Old Smoke, touring his former domain.

Most other phenomena here are attributed to Old Smoke, including anything related to gambling implements. A Skidmore student was freaked enough to run by a spontaneously spinning roulette wheel, credited again to Morrissey. And he—if it's him—can be a prankster.

A Saratoga cop took a private overnight security job at the Casino. In acknowledgment of the station rumors, he brought two flashlights, both well charged. Both cut when he was on patrol upstairs. He had to feel his way

down, all the time sensing "eyes upon him." When he got to other parts of the building, the flashlights operated normally. He never worked there again.

The Casino/Museum is an active site. If you went once a year and interviewed each member of the staff, you would come up with new and different reports. The lion's portion of whatever turned up would be blamed or credited to Old Smoke. Who else could it be? Somebody that no one can see must be smoking that aromatic cigar whose fragrance can sometimes be detected, but faintly, like the echo of a sound or the wake of a wave. Spirit, if he is, he sips now at the wine breath.

Last Mistress of Pine Grove

No greater love than this, oh brave and loyal soul,
No nobler loosing of the golden cord,
Thy life was given to Duty and thy country
And in God's peace thou hast thy rich reward.
—Mrs. Morris P. Ferris

The Walworths of America have a book. One who ought to know—a Walworth named Clarence—wrote it. That family has a mighty strain of propriety—war heroes, society founders, judges, authors and community pillars. It also features strains of, as Robin Williams puts it, "full-goose bozo"—alcoholism, abuse, insanity and murder. Life for some Walworths was a roller-coaster ride. We're reminded of one of Faulkner's epics, except that we're a bit far north. Always, though, there was the name: Walworth. It carried quite a cachet. One about whom there seems to have been no aura of anything but admiration was Judge Reuben Hyde Walworth (1788–1867) of Saratoga Springs, a chancellor of New York State and second owner of Pine Grove, a mansion that would be a story in itself. Pine Grove was Saratoga's *Wuthering Heights* or *House of Usher*.

The fifty-five-room mansion that once stood on Broadway may have had its brushes with the psychic from its early days. In 1815, Judge Henry Walton built Pine Grove at 525–527 Broadway. One of his daughters had a storybook engagement to a young and successful man who crossed the Atlantic to finish an important deal. As he sailed home to the wedding, the Walton daughter had one of those dreams strong enough to seem real, marked by groans, despair, torment and the sounds of a pounding surf. So terrible was the experience that it marked the morning's conversation, during which the

fearful message arrived: there had indeed been an accident that had taken many lives, including that of the girl's fiancé. Word is that she fell apart, and had to be hospitalized for the rest of her life. The grieving judge sold Pine Grove to its second owner, Judge Reuben Hyde Walworth, grandfather of the star of our tale.

Reubena Hyde Walworth (1867–1898) was raised in Pine Grove, the magnificent wooden mansion that once stood on the west side of Broadway, not far north of its crossing with Lake Avenue. The Vassar graduate known to her friends as "Ruby" was a pretty, fair-haired woman with a lot to live for. She was even a writer, the author of a whimsical drama, *Where was Elsie? or the Saratoga Fairies*. But she, too, knew sadness. Three of her siblings never made it past infancy, by which they certainly avoided trauma. No child of the abusive novelist Mansfield Tracy Walworth had an easy go in life. Reubena's brother Francis Hardin Walworth ended the family terror by shooting his own father. Parricide and insanity will always mark his memory. His name isn't even mentioned in one family biography.

Sister Reubena restored the family honor, serving her country as an army nurse. She was thirty-one when she contracted some ailment thought to be typhoid from the Spanish-American War veterans at the hospital at Montauk. Her October 18 death in New York City set the DAR and countless preppies into paroxysms of poetry. She was buried with full military honors at Saratoga Springs' illustrious Greenridge Cemetery. One of Saratoga Springs' mighty Women in White, Reubena may have more than one location and possibly more than one kind of ghost.

At the famed Casino in Congress Park, Reubena may be a "ghost pertaining to place." (The TV ghost hunters today like to call this residual haunting.) This type of apparition is very site specific and seems completely un-self-aware. It is going to do its limited thing no matter who or what is watching. "Ruby" has been reported a number of times at the Saratoga Springs History Museum, which holds many artifacts of the Walworth family and home. Even visitors to Saratoga Springs have been shocked to see her apparition walking the upper halls. In one case, a tourist nearly fainted when shown the actual dress the surreally silent form in his vision seemed to be wearing.

Reubena's other form may be that of the "ghost pertaining to people," my second category of ghost, far different from the first. In other terms, this is the classic "crisis apparition," this one seen in the family home, Pine Grove. For a ghost sighting, it is exceptionally well recorded in the *Chronicles of Saratoga*. Author Evelyn Barrett Britten experienced it.

Clara Grant Walworth (1886–1952), last mistress of Pine Grove, was the only daughter of the parricide Francis Hardin Walworth. She was Reubena's niece. Clara had had a bit of a struggle in life, having to work quite a bit harder than the typical Saratogian with that big of a name. Possibly as a means of expiating this family karma, the spinster Clara stuck it out to the end in Pine Grove. On the night that would become her last, a round-the-clock watch was kept by a family friend, author Evelyn Barrett Britten, and several nurses.

Clara Walworth's main nurse seems to have been Mrs. Bessie Lewis, with aid from Georgianna Slattery. At the start of one of Ms. Slattery's shifts, she came to the dimly lit room where the patient lay. She was surprised to see another nurse, one she did not know. Ms. Slattery went back to the writer and whispered, "Mrs. B., you got another nurse?" The pair turned and saw the figure of a young woman in an old-time nurse's dress. This stranger bent over Ms. Walworth so that her strawberry blond locks seemed to spill over the aged patient. Then she vanished. None doubted, after a spell of thought, that it was Reubena they had seen, coming back to comfort the last mistress of Pine Grove and escort her into the spirit world.

No storm of praise will be bestowed on her,
Sweet nurse—yea angel—gentle minister.
And yet she served her flag—not as a man,
But better still, as only woman can.
—Charles Hanson Towne

HATTIE

It's not rare for two haunted sites to be close together. Sometimes these things operate in clusters, as if the very ground is energized, radiating some sort of force that either makes psychic effects act up or gives people the impression that they do. It is rare for two spirits this noteworthy to be neighbors. Lena and Hattie are two more of Saratoga Springs' mighty spiritual females

The side-by-side sites at the edge of the second block on Phila Street may be remarkable cultural landmarks, but they are not architectural ones. The building housing Hattie's at 45 Phila seems to date from 1938, which was also the start of Hattie's business at her original Congress Street site.

It may not be obvious everywhere on Broadway, but Saratoga Springs has an ample community of African Americans. There is even a book on

Hattie's.

their local culture in which the author calls them "Afro-Saratogians." I knew a few of them when I lived in Saratoga Springs in the 1970s, and my first recollection of any mention of the legendary Hattie Mosely (1904?–1998) came with the comment of an aged Afro-Saratogian who refused to go into her restaurant. He objected neither to the cooking nor the proprietor. He simply felt that, as he put it, "Hattie has voodoo." Hattie was a power person whom it would be disaster to cross. The best way to avoid that possibility was never to cross paths.

Hattie Austin Moseley of Baton Rouge, Louisiana, came first to Saratoga Springs as the traveling cook of a Chicago family who summered here. When time came to branch off on her own, Hattie never looked back. The Springs was the place. She may have started out in 1938 selling chicken and biscuits to racetrack stable boys. From there, it was an easy progression to a restaurant. Her first establishment was on the side of town called Saratoga's Harlem. By 1969, when she moved to 45 Phila, Hattie's—and Hattie—were Saratoga legends, dispensing southern "soul" and Creole cuisine to generations of the enlightened.

Many Saratogians remember Hattie's husband, Bill Moseley. He may have once been a Pullman porter and was definitely a former prizefighter.

The mister Moseley always greeted people at the door with something—a towel/placemat/cloth of some kind—folded on his arm. But everyone remembers Hattie: remarkably warm to one and all but putting up with no nonsense. She once threw a pail of cold water on an over-served customer who refused to leave.

This couple was memorable in ways that didn't show, too. Word on the street is that they took in a lot of troubled kids over the years and tried to put them on the right path. They helped them learn the restaurant trade, too. They hired them, trained them and life-coached them.

Hattie had psychic clout of some kind, possibly what the Irish would call "the sight." One story that surfaced in the papers is a good one. In 1992, a lovely young woman with a job on Wall Street happened to be in Saratoga and dining at Hattie's. She fell into conversation with Hattie, and the two hit it off marvelously. As they made their goodbyes, Hattie looked intently at Christel MacLean and said, "You will own this restaurant someday." Nothing of the sort was on Christel's mind. In 1996, the prophecy came true.

In 1998, Hattie Moseley made a little visit to the hospital for a checkup nobody expected to be significant. She was over ninety, but hale and spry. A longtime cook cleaning the fryers remembers the moment that the front door blew open and a dramatic sequence of psychic phenomena followed. A cool breeze rustled through the building and into the kitchen as if something mighty and invisible had gone right by him. He and others found out later that that had been the approximate moment Hattie had passed from the world.

It is rare that anyone reports Hattie's image anymore, but it's common knowledge that her presence is still here. In 2004, the cook who had that experience swore that she was around all the time. He said he still talked to her. If anyone doubted her whimsical presence, there was a bit of physical phenomena to remind them. There are still common occurrences of little poltergeist pranks—SPOTUK. Objects are moved around overnight. Appliances found in the morning on or off had been left off or on the eve before.

Voodoo or not, Hattie knew what the business was. One bright sunny morning, a reporter came to interview Hattie, who had come in before daylight and was busy in the kitchen. The reporter noticed an odd display on the step: two ordinary white sticks, about two feet long, peeled white and made into a cross. A simple white stone not much bigger than a pebble rested in one corner of the quadrant (I think it was the northeast corner). Making no more of it, the reporter stepped over it and inside.

She and Hattie laughed and talked for ninety minutes and felt like old friends when they parted. Only when Hattie walked the reporter to the door

did she see the strange configuration, and there the mirth was broken. Hattie leaped with a spryness past her years, kicking stick and stone scornfully and spitting something into the air at imagined enemies. It sounds as if somebody was after her with juju. It doesn't sound as though it worked.

Whatever Hattie was into, I would not presume that it was "evil." I met her a time or two and didn't feel a bit of negativity from her. I would expect her to have stood up for herself in whatever domains were relevant to her. There is a crawlspace under the basement of Hattie's, pressed right up against Lena Lane and open to the air. In 2005, I interviewed an employee who had done some cleanup under the building and reported that a variety of animal bones had been found under there. They looked old and had bits of yarn and trinkets on them. Somebody here was up to something.

LENA

Another of Saratoga Springs' mighty twentieth-century personalities was born in Milford, Massachusetts. The youngest of eight, Pasquilina Rosa Nargi (1923–1989) may have developed a need to set herself apart. Throughout her childhood she had dreams of becoming a singer, an actress or a performer of some type. By her thirties, the inspiration of a bigger cause took over. She wanted to open up a café and theatre for the performances of others in a budding, socially conscious wave—the American folk movement. A run-down building close to the Hudson Valley and a few hours' north of New York City beckoned. In 1959, Lena came to Saratoga Springs with sculptor Bill Spencer and started the long renovation. Caffè Lena opened in May 1960.

Bill Spencer gave up early and went back to Boston, some say, with a slinky young performer he met at 47 Phila. Lena soldiered on.

Caffè Lena was a bad endeavor for someone who wanted to be a millionaire. For anyone who wanted to be one with the times, it was a miracle. The list of performers was impressive: Bob Dylan, Rosalie Sorrels, Don McLean, Arlo Guthrie, David Amram, Phil Ochs, Ani DiFranco, Jack Elliott, Jim Kweskin, Tom Paxton, Jean Redpath, Patrick Sky, Dave Van Ronk and Loudon Wainwright III.

Volunteers led the show and dispensed tea and coffee. The patrons came from all over. Few can forget the image of Lena at the table at the top of the stairs, taking the gate beside her Siamese cat, Pasha. Laughter and singing often went on late into the night after the shows. Surely this left some essence.

Caffé Lena.

But Lena Spencer did more than run a small business. She nurtured talent and performers. Some of those following their dreams couldn't afford a place to sleep. Lena gave them a couch. Some who wanted to stay in Saratoga Springs had to have employment. Lena did all she could. Word has it that one who took the latter offer was Don MacLean, composer of the curious 1970s hit "American Pie." (He may have worked at the legendary Caroline Street bar "the T&L"—Tin and Lint—where his nickname was something like "the Slug." As would figure of a young poet bussing tables, MacLean was spacier than he was speedy.)

Caffé Lena held a stage, the Black Box, which hosted plays, both traditional and experimental. Spalding Gray, John Wynne-Evans and David Hyde Pierce made appearances in the 1970s and 1980s. Even a company, Home Made Theatre, started at Caffé Lena. Lena's contributions were recognized by a number of honors and awards. A lot was due. Number 47 Phila is a shrine to the American folk movement. It may hold influences of another sort.

Many longtime friends of Caffé Lena reported a sense of heightened sensitivity about the building as if it held a spirit guardian. It grew stronger as long as Lena lived. On several occasions, people who claimed psychic abilities were impressed with something, too; something that two of them described as the presence of a young man. Lena herself, the old-timers say, looked a little wistful when anyone brought the subject up. One I spoke to

sensed a presence very strongly in the entranceway, at ground level, at the foot of the stairs. When Lena fell, she was found in the very spot. Someone on one of our August 2006 tours took a picture there, and it held a strange, blurred humanlike shape.

Many conjectured from things Lena said over the years that there may have been someone from her past that she never told anyone about. It would be something to know who he was. No one doubts that Lena is still here. If there is one figure in this chapter that is more spirit than spook, it is Lena.

The Ninth Guest

On August 6, 1887, James and Rosa Burns became parents of a little tyke who would prove to be a studious, serious sort. Daniel Robert Burns went into religious studies at Holy Cross in Worcester, Massachusetts, and St. Mary's in Baltimore. On the winter solstice in 1913, he was ordained as a Catholic priest by Bishop Thomas Burke. Young Father Burns went on to assignments at an Albany Hospital, at Great Meadow Prison and as a chaplain with the U.S. Navy. Doubtless, he saw a good bit of the world that he wasn't going to see in church or college.

Father Burns went on to serve at churches in Troy, Fort Ann and Fort Edward and, ultimately, at St. Peter's in Saratoga Springs. He was fifty-seven when he came to this big, successful church in a plum community. The parish was here long before Father Burns, and a church on South Broadway stood by the mid-nineteenth century. In due order, a school, a rectory and expansion followed. Father Burns touched a lot of life in the big congregation, presiding over births, marriages, deaths and funerals. He was well thought of in the church, too, eventually to be called "the Monsignor," the traditional address of priests who have received many awards and titles. Saratoga Springs must have seemed a heavenly place to him because he retired to the rectory at St. Peter's, right there on South Broadway, within the overlook of Congress Park. He—or some essence of personality that others attribute to him—may never have left.

A cluster of SPOTUK effects concentrates in the rectory to which Father Burns retired. It is not very personalized, but that doesn't stop most people from presuming that it's the activity of the Right Reverend Monsignor. An example of it might be the elevator that Father Burns had installed for the convenience of the older priests. After Father Burns's passing, it operated spontaneously

now and then, as if for the transit of its famous invisible passenger. Even years later, in periods when the power to it has been off, something recycled the sound effects. Many residents of the rectory have experienced this. Everyone considers it the influence of Father Burns, just checking up.

By now, you are familiar with the George Washington effect. It is fairly natural that the SPOTUK at any site is attributed to the most memorable late person. However, Monsignor Burns may show himself more directly than we find at most haunted sites.

David Pitkin summarizes a lot of excellent material that we would not have had without him. The most dramatic includes the story of a phantom image—an "extra" presence—in a room of local priests, appearing so natural that the cook, scanning the room, set a ninth place at a dinner table. She was confounded when only the expected eight came to sit. Weeks later, she came upon a photograph in which she recognized the ninth guest, Father Burns, dead by then for a decade.

MALCOLM

Not much gets said about this chunk of a building in the books on Saratoga architecture. The several buildings in one at the southwest corner of Broadway and Caroline Streets is sometimes classified as Greek Revival, early style. There may not be much architectural curiosity about the site of the former Professor Moriarty's, but in other senses, there may be mystery.

It isn't much of a shock that something called Professor Moriarty's would attract ghost stories. Intrigue goes with the name of master detective Sherlock Holmes. His creator—and that of his arch villain, the nefarious professor—was one of the Victorian world's most ardent spiritualists. Psychic communication and outreach to the dead were never far from the mind of Sir Arthur Conan Doyle (1859–1930). Doyle traveled the world, and wherever he went, he visited prominent psychics, hoping to speak to the spirit of his son. A frequent guest and travel companion was the stage magician Houdini (1874–1926), likewise on the quest to get in a few words with his late mother. It is one of the ironies of their association that the greatest magician in the world never met a psychic he believed and that the creator of the world's archetypal detective never ran into one that couldn't fool him. Whatever cachet comes with a simple name, "Professor's," as everyone called it, was a Saratoga original.

430 Broadway.

Professor's was born in April 1984, when two owners of Saratoga's still-thriving classic Tin & Lint pub decided to take a crack at a Victorian-themed dinner pub on Broadway. Professor's was known for its nonexperimental—English, American and Irish—fare, its spectacular wood bar (itself almost a piece of architecture) and the deeply Victorian imagery of its menus, merchandise, displays and graphics. It looked so much like an old English dining club that its namesake would have felt right at home. For nearly a quarter century, Professor Moriarty's thrived. On March 19, 2007, Professor's owners held their final party.

As distinctive as it was for its imagery and ambience, the site may have had psychic energy due to things that preceded Professor's tenure. Longtime staffers reported a variety of mild psychic effects seemingly from the Professor's inception. By consensus today, though, 430 Broadway has one clear ghost. People still talk about Malcolm.

Lifelong Saratogian Malcolm Driscoll (1909–1992) graduated from the school of the Church of St. Peter and was an American army veteran of World War II. He started working as a letter carrier for the post office and retired as superintendent of mails in 1972. Before long, the bug to do something got to him, and he started as a night cleanup man for Professor Moriarty's. This distinctive, elderly man with the flowing white locks and beard was a beloved figure at Professor's. There are many stories about him.

The first clue that there was something more than met the eye about Malcolm should have come when he showed for work his first evening in his jazzy convertible, ashy locks swirling in the draft. Malcolm, we hear, didn't need to work. It was said that he was a millionaire.

A merry sort, Malcolm was a fine dancer. People could come in late at night and be surprised to see him swaying in perfect rhythm with the reggae he liked to play on his little blaster. He had a spot in the basement prep kitchen where he used to nap during the night, they say. But no one cared; his work was always done come morning. They also say that he claimed to be friendly with "the spirits" of the place, possibly even talking to them during his long nights. We can only guess what he would have said upon hearing that he would someday be numbered among them. Owner Dale Easter found him one morning in 1992, seated just to the left of the bar, slumped over a table like he was napping. Until the end of Professor's run fifteen years later, people attributed everything awry to the impish presence of Malcolm.

They heard his footsteps. People who knew him reported his apparition, sometimes swaying to the phantom reggae they could faintly hear. On at least one occasion, someone reported the impression of a couple of fellow dancers in the background, as if, become a ghost, the worthy Malcolm had summoned back with him the Bob Marley chorus.

To be honest, I hear so many stories about Malcolm—before or after his dive out of the daylight—that I wonder if all my subjects can be talking about the same person. I can only tell you what I have been told.

Today, 430 Broadway is Cantina, a thriving establishment specializing in Mexican fare and beverage. Those who remember Professor's fondly will find most of the same ambience, just a change of menu and décor. They still think they're haunted at Cantina, and by the revered Malcolm. Still a prankster, Malcolm—or whatever they attribute to him—tips little things over, tweaks hanging pictures, fools with the lights and flushes toilets in empty bathrooms. One of his tricks in life was to turn off the overhead lights by grabbing the longest pair of tongs in the place, reaching up and pulling the switch. It is one of his tricks now, and he has a less visible way to do it. How long will he be with 430 Broadway and the site of the former Professor's? A character still, this is one presence that would be missed.

Saratoga Is Portals

The graduate English department at Boston College is strong but small. A semester came up when I didn't see a thing I wanted to study. I took a half year off to try to scrape by somewhere atmospheric and finish a book, an occult novel I was too young to write well.

I ended up on Labor Day in a cottage on the east side of Saratoga Lake, not far from Snake Hill. The one-level structure was a good ways off the lake and on the slope of a hill. One end was on stilts ten feet off the ground. The other was low, its windowsill four feet over the grass. The small, open-air back porch looked out on mysterious woods to the east that went pretty far before coming to a thin rural road and then continuing. Something felt creepy about it from the beginning.

The day I moved, the back porch was bare. The next morning, it held a curious old-time wooden garbage can, stained pine green. In the clean bottom was a pair of high-heeled women's shoes, painted a lurid green. Lain across them was a butter knife, sharpened into a virtual weapon. I know the old Euro symbolism of green—magic, witches, fairies—and facing a wood like that, it was hard to escape the connection. The contraption was waiting for me at the end of the day when I returned, but by morning it was gone. It had been placed and taken away at night by someone I could only associate with those woods. I took it as a message, but of what?

My landlords lived downhill by the road. The husband was a sixty-something, middle-sized rural fellow who seemed to lack immaterial speculation. His full-figured, thirty-something wife was a devout Christian, possibly born again. We got on well, though I didn't see them much in

the three months I was there. But once I told my landlady about my studies—Romantic-age poetry, mythology—and the book I was trying to write. That got her worrying about my soul. During our last conversation, she was so desperate for me to visit their church that I promised I would. Not only did she sense the devil everywhere, but she also believed that the power of that building was so strong that a step inside the door would make a change.

I felt other things coming to a crescendo as I readied to move out. Some sinister symbolism seemed to be at work in minor events and piling up. Maybe I had been too impressed by the films of Fellini, Roeg, Bergman or Polanski. I felt like the lead character of almost every Lovecraft tale, whose understanding grows as the stalking force closes—until I was out of that house.

The day before I left, I had an accident. The warm November day was so inviting that I had biked to the Stillwater battlefield. Some grit in a pickup brushed me off that high ten-speed, and half the skin on my back stayed on that road. I can't imagine worse agony. I had to sleep on my stomach to catch a wink. I wasn't in a happy mood when, about 3:00 a.m. on my last night, people were running around that house. They were under the high bedroom, their laughs resounding in the hollow space in the stilts. Their shadows came in the windows, silhouetted by some variable light source that seemed to be behind them. They knew I was leaving! They were taunting me!

I grabbed an unstrung tennis racket, slipped out over the back porch and tore into almost total darkness. I wanted to get into the trees, let my eyes adjust and come in on them from behind. I gave it a good long run round and couldn't find anyone. I wasn't sure what to think.

I moved into town, lived a couple more months in Saratoga Springs, finished my master's, and ended up teaching school near Buffalo, New York. Ten years after my Saratoga stay, I passed through on the way to Vermont. I walked all over the town on the Sunday night before Christmas. The college kids were gone, the stores were closed and the pubs didn't have a touch of their usual life. The whole village seemed tired and happy to be out of the wind that smoothed all the city sounds and the faint, steady snow that muted light and made shadows out of fellow walkers. One place, though, was so alive that I could hear it a long way off. Drawn by the percussion, then strains of music, I came toward it.

The source of all the shakin' was a church on Henry Street near Caroline. It wasn't one of the old classics in town. It looked like a wood-framed commercial building onto which churchy features had been grafted. It

dawned on me that this had to be the church of my former landlady. I also remembered my promise. I entered.

The church was almost packed, and the service was in full swing. No one saw me as I took a seat in back. The song that felt halfway done when I came in hopped along another eight minutes, and nobody was getting tired. I got the feeling that this event would go on all night. Then things slowed down. A white preacher came out and did a bit of talking. An organist contributed occasional chords and riffs, that gospelly mix of funk and inspiration.

Then the testifyin' started. A handful of whites came to the altar and shyly let it out in general terms. None of them took more than two minutes. Then a small forty-something black guy got up and confessed so long and in such detail that I got the feeling he liked remembering what he used to do. But the mood of the church was changing. Soon, he was so out of rhythm with it that even he felt it. The preacher took over again and said a few words. People had already started to sway, as if everyone knew some moment was at hand.

Then came the women. Slowly, quietly, several forms entered the light space below the preacher. I was startled to recognize my former landlady's blocky form topped by that same bouffant hair. Like a megalithic circle rooted by a menhir, these women fell into a ring below the altar and soon were in an ecstatic trance. They made odd music.

They moaned, they trilled, they swayed. I had never seen anything like these born-again bacchanals, mature women swooning and groveling at the center of the nave, dancing from their knees.

I was fascinated, as if I'd been observing through a time lens one of the rites out of Frazer's *Golden Bough* or Graves's *White Goddess*. What was this operative in living, reasoning people in the most developed country on the planet? What was this flight from consciousness, this willing step out of the self? Was the capacity in all of us? Was the inclination? Was it dangerous? I stared, as abstracted as they were into my own processing.

I was realizing something else: the temperature had risen. It was no illusion. Could there be other material changes? With my eyes, I studied all parts of the building.

Something was growing and had been for moments—a rising, spiraling sensation of force from the region of the women at the nave up into an imaginary vortex. I could see some distortion like a heat haze in any features above the women pale enough to be distinct. I could not have been mistaken. Some effect above these Christian maenads was visible. It was even variable,

as if it wasn't a wake off the group like smoke from a fire but instead made of individual spirals from each supplicant, radiating out and up so that the distorting effect worked in bands like a stuttering calyx. I watched long enough to be sure. It was too much. I stepped out into the street, doubtless unnoticed again.

It has been years, and I remember that night, the first time in my life that I suspected that something objectively powerful and beyond our knowing might be involved in a form of a religion that I'd been taught by the media and the climate of the American college to despise.

That building stands. Today, it is called "the Soul-Saving Station for Every Nation." It probably is the denomination it was then, in the late 1980s. I am still not sure about something at that place. If I had to pick a religion for myself tomorrow, it would not be that form of this one. But make no mistake. Whatever people believe, whatever you believe about it, the power of belief is something that cannot be dismissed, even as we near the interplanetary age. There could be something paranormal about it. I advise that you treat it, and that church, with respect.

As Macbeth's gatekeeper says of his flight of whimsy: "I'll devil-porter it no further." I've come to think that I'm ready to summarize Saratoga, at least for this stage in my life.

Saratoga is portals. It is a place of visionary, possibly spiritual, entry. That can mean that people and things here seem to state nothing beyond their own display and also that it is a place where people grow by the experience of seeing. Like the right sort of crystal or one of its spring-fed pools, Saratoga has both surface and depth. It reflects whatever comes to it and holds interiors that generate inspiration, all depending on how you look. Why wouldn't people see a few ghosts here?

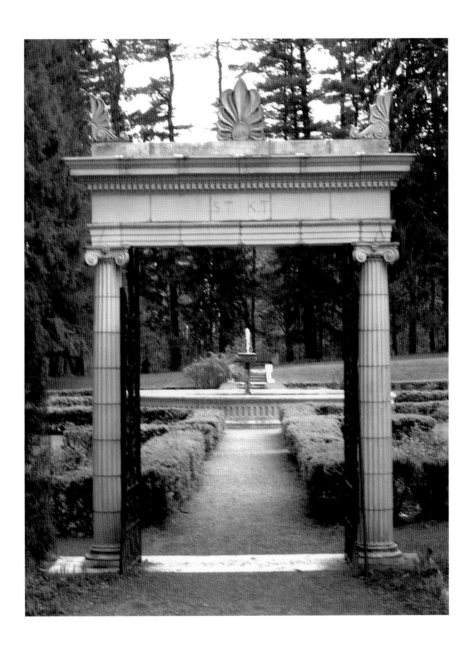

ABOUT THE AUTHOR

Mason Winfield studied English and classics at Denison University and has a master's degree from Boston College. For thirteen years, he taught and chaired the English Department at the Gow School in South Wales, New York. The founder of the popular touring company Haunted History Ghost Walks, Inc., and a cofounder of the research organization Spirit Way Project, Mason is dedicated to causes of historic, architectural and cultural preservation. This is his eighth book.